P9-DEB-648

FACES
from the
PAST

Also by Richard M. Ketchum

The Battle for Bunker Hill
The American Heritage Book
of Great Historic Places
Male Husbandry
What Is Communism?

FACES

from the

PAST

RICHARD M. KETCHUM

AMERICAN HERITAGE PRESS • NEW YORK

For Bobs

CONTENTS

FOREWORD

This is not a book of photographs, although it came about because of a love for old pictures. It is really a collection of the strange or exciting or sometimes inspiring stories suggested by these faces from the past, and it began with the idea of relating a particular photograph to a particular moment or time in an individual's life.

So often a photograph captures the very essence of a man or woman in the instant of sadness or joy, or at what Henri Cartier-Bresson calls "the decisive moment"—an individual with his guard down. Thanks to the photograph, we look into the dimming eyes of a man born long before the American Revolution, whose childhood held memories of the French and Indian Wars. Here is a man who clasped Abraham Lincoln's hand; there the assassin who struck him down. To see Billy Sunday's face is to glimpse some of the old magic that took folks down the sawdust trail; to look at the Okie woman and her three children is to comprehend, and weep for, their plight.

The photograph, when it burst upon the scene in the 1840's, became the material of history—a kind of talisman for the future, enabling us to see a person as he was, with the warts or wrinkles or the drooping eyelid, the high starched collar, the heavy, unpressed wool suit. We smile at the dress and hair styles of another age, at fashion's passing fancy, but beneath the surface lies more. Certain photographs enlarge upon what we find in letters or the pages of a diary, challenging us to look further, to perceive not only what was in the face but what may have been behind it. Most people in the early day of photography, as ever since, had an urge to perpetuate themselves by means of a photographic portrait, and now and then the photographer, if he was lucky or gifted—or both—succeeded in capturing the true identity of his sitter as well as a likeness.

Oliver Wendell Holmes described photography as "the mirror with the memory," suggesting what it could mean to the historian, for the historian's purpose is to see things as they really were, to locate, behind all the obscuring darkness, the essential truth as nearly as it can be discovered, and before the advent of the camera he often had to search for a man's image with eyes that could not see.

There is no exactitude about the first photograph to have been made in the United States, but the first surviving daguerreotype, taken by one Joseph Saxton, was made late in 1839. At best, then, less than a third of the time that has passed since Christopher Columbus' first voyage to these parts has been documented in any way by the camera. The period of the daguerreotype—Louis Daguerre's process by which an image was recorded on silver-plated copper—lasted until a little before the Civil War, when the "wet plate" came into use. This new method produced a negative on glass and permitted the photographer to make as many prints as he desired (a daguerreotype was a one-of-a-kind proposition, from which no extra copies could be made).

In those primitive years of photography it was necessary for the sitter to remain motionless before the camera for a matter of minutes, customarily with a clamp, mounted on a stand, holding the head in place to keep it from moving. In the absence of artificial illumination, the long exposures required were made in natural light. Not until 1888 and the invention of flexible film by George Eastman did photography regularly achieve what might be called "instantaneous exposure." Thereafter the photographer was more likely to catch his subject in an unguarded, or at least unposed, moment—occasionally without the subject even knowing that his picture had been taken.

Most of the photographs reproduced here have a close relationship to a particular event or time in the individual's life. In the case of Franklin Pierce or of Robert E.

Lee, for instance, the moment at which the picture was taken has special significance. Sometimes—especially in the early days of photography—a sitter posed but once for a portrait, and that is the only image that exists; but whenever there was more than a single picture from which to choose, the one that was closest in time to the event described was selected for reproduction here.

The lives of the people touched upon in this book span nearly two hundred years, and while this is in no sense intended as a history of this country, it is another way of looking at the past. History, after all, is the story of people and what they have done—perhaps no more, as Gibbon contended, than the record of the crimes, the follies, and misfortunes of mankind. Beyond the individual lives that make up the past there is a continuum, a web of succession by which all may be related, and it is interesting to speculate on the way time, if not circumstance, can juxtapose certain lives. J. P. Morgan and Julia Ward Howe are among several people whose faces appear in these pages who were, on the one hand, born early enough to have known Major John Livingston, and who, on the other, lived well into the twentieth century—long enough to see the electric light and the telephone, automobiles, and the first airplanes. They knew something of the modern world, yet from the standpoint of time, their lives reached back to overlap that of a man born in the year of Braddock's defeat, during a war that was fought to determine whether North America would be ruled by Louis XV of France or George II of England.

It seems probable that Major Livingston, whose daguerreotype portrait is reproduced here for the first time, lived before any other American of whom we have a photographic likeness. He and many other figures in this book passed their days in a world only remotely resembling ours. Their voices are still but their faces, if we will pause long enough to look, have a way of speaking for them.

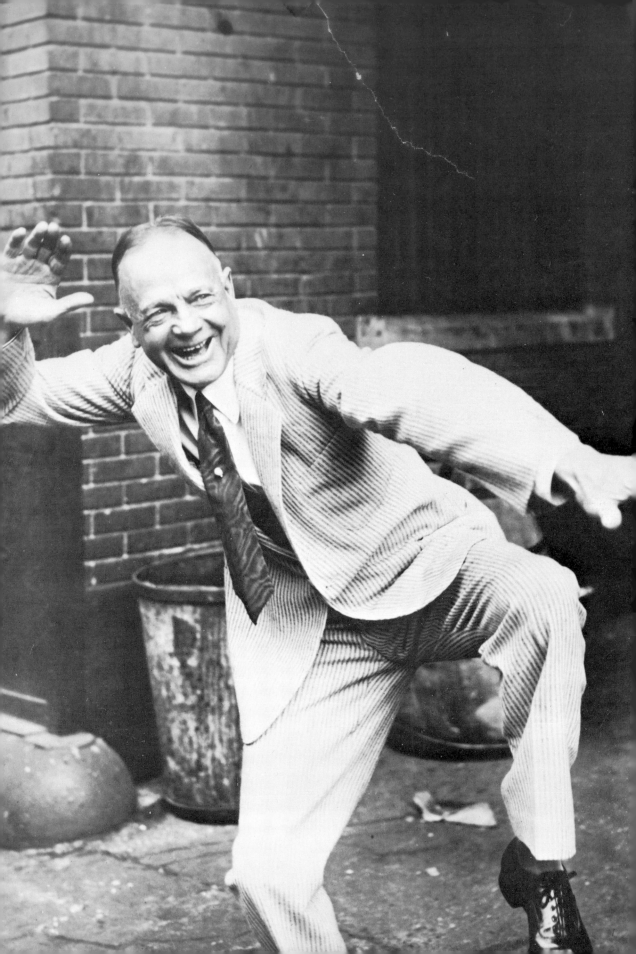

Just by luck, the same summer the Marshalltown fire brigade needed a fast man in the worst way for the fire-fighting competition, someone spotted this youngster from the orphanage, who could run like the wind. To show what an exalted honor it was to belong to a fire brigade, the boy joined up even though it meant missing his high school graduation. There were firemen's tournaments all summer, but the brigade didn't take full time, even in Iowa, so he hired out to the local undertaker — $3 a week, and enough time off for baseball, which suited him to a T. With him playing outfield, Marshalltown won the state baseball championship in 1883, and the great Cap Anson saw the boy and made him an offer. Now, being noticed by Cap Anson and being given a tryout with the Chicago White Stockings was as close to paradise as a lad could get in those days, and when he arrived in the city in a green suit with a dollar in his pocket, the pearly gates were in sight.

His real name was Billy Sunday, but the players called him hayseed and rube on account of his suit and playing ball in Iowa, and the first thirteen times at bat he went down swinging. Then the fastest man on the team challenged him to a hundred-yard race, and when Billy, running barefoot, beat him by fifteen feet, they figured he might catch on after all. For eight years he played ball — 1883 through 1890 — and one season he stole ninety-five bases. The only man to beat him, Billy claimed, was Ty Cobb, and that wasn't until 1915.

In spite of his running, Cap Anson finally decided he was one of those fellows you might call good field, no hit, but what took the heart out of baseball for Billy was falling in love with a girl from the Jefferson Park Presbyterian Christian Endeavor — that and coming out of a saloon one day and running smack into a group of evangelists, hearing their gospel hymns, and getting converted. From then on it was all uphill, straight and narrow — no more drinking, swearing, or gambling, but talks at the Y.M.C.A.,

revival meetings, and a celluloid collar. America had seen revival preachers before—there must have been 150 years of tents and wooden platforms, calls to sinners, preachers running down smoking, chewing, drinking, dancing, and card-playing Christians—but no one had seen the equal of Billy. He blew in from the Middle West like a twister, telling folks he was nothing but a "rube of the rubes," and by 1911 his name was better known than any of your foreign princes. "Get right with God!" was the motto. The church needs fighting men, not those "hog-jowled, weasel-eyed, sponge-columned, mushy-fisted, jelly-spined, pussy-footing, four-flushing, charlotte-russe Christians." Why, he could work himself into a rage against the devil till the sweat poured off him in a stream; then he'd shed his coat and vest and tie, roll up his sleeves, all the time crouching, jumping up and down, shaking his fist, and running back and forth across the stage.

Sometimes he was a sinner trying to slide into heaven like a ballplayer—and he would run the length of that stage and put on the prettiest hook slide you ever saw. "Lord," he'd say, "there are always people sitting in the grandstand and calling the batter a mutt," complaining that he can't hit, he can't get the ball over the plate, he's an ice wagon on the bases. "O Lord, give us some coachers out at this Tabernacle so that people can be brought home to you. Some of them are dying on second and third base, Lord, and we don't want that." And then the old outfielder would leap to the edge of the platform, crouch there with one leg stretched out behind him, his arms pointing to some "boozer" in the audience, and holler out that a man who drank was a "dirty, low-down, whisky-soaked, beer-guzzling, bull-necked, foul-mouthed hypo-crite!"

Once he described how Christ might divide the world, saying to him, " 'Bill, you take Massachusetts.' If He says 'Reign over Massachusetts,' there'll be something doing . . . I've got it in for that gang." When he got to Boston he

held a "Scotch Night," and called to all those fellows in kilts: "Come on, Scotchmen. Show some of the grit of Wallace and Bruce!" Anyone who held back from hitting the sawdust trail, he said, had the "real, genuine, blazing-eyed, cloven-hoofed, forked-tail, old devil" hanging on his coattail. And he never forgot baseball. "Lord," he would groan, "there are a lot of people who step up to the collection plate and fan." Then he'd lash out at cheapskates who were too tight to pay for religion: "Take a stand and get into the game!"

For nine years it went like that, audiences growing bigger all the time, flocking to hear the man who fought the enemies of God and America and motherhood and hard work. How they loved him and his smile, the friendly, boyish figure in the natty suit; every week there were thousands of "decisions," with men and women walking down the aisle to shake Billy's hand. Somebody figured he spoke to a hundred million people—and that was before radio or television—and brought a million down the trail. Then it was over. Something happened to America in the First War, and that was the end for Billy Sunday. All of a sudden it seemed as if he was trying to turn back the clock, to make believe this wasn't the twentieth century but the nineteenth, and before long he was dead in the big towns. Oh, he still held meetings, of course, but they weren't a patch on the old days.

By 1928 newspapers didn't even bother to cover them, so when he arrived in Detroit he dropped by the *News* office just to let them know he was there. A photographer decided to get a picture of him in case the editor ever did run a story, and took him outside to the alley to pose. What he got was the old Billy Sunday, all right—stickpin and a big smile, same natty suit and peppy pose—except that Billy was sixty-six now and most people weren't interested in what he had to say. The simple answers and "Brighten the Corner" weren't enough any more.

17

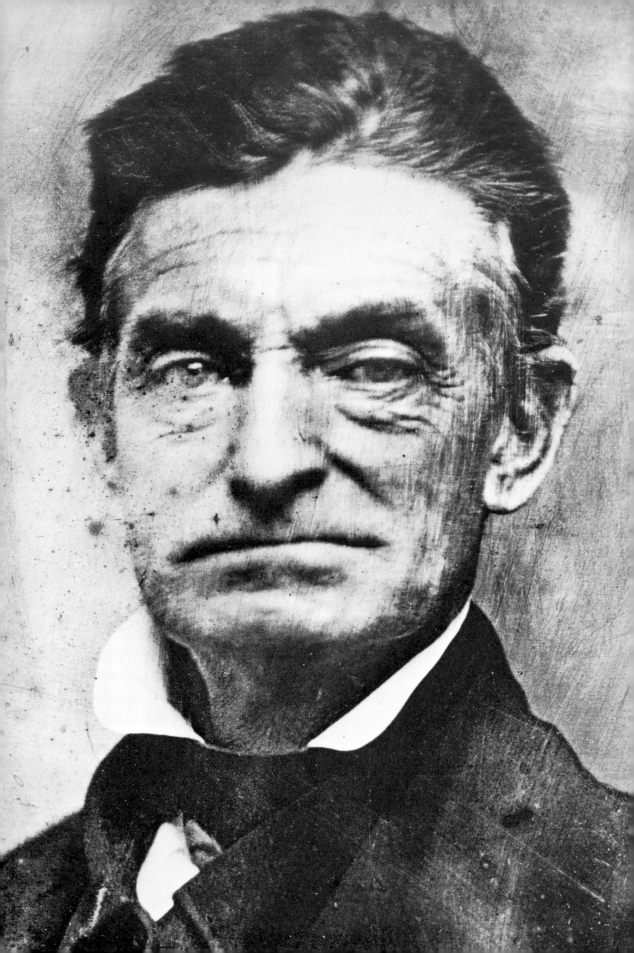

Old Brown, they called him, Brown of Osawatomie, John Brown, messenger of the Lord or murderer, liberator or lunatic, depending on the point of view and which side you stood on. Place a hand over one half of his face, then the other, and see that there are two men there, a personality split as surely as the Union was in the tortured decade of the 1850's. There was the hard, brutal, possibly demented Brown, the man who had gone to Kansas in 1855, following three of his sons and the contagious wind of abolition in an effort to prevent slaveowners from creating another slave state. In May of the following year, when this photograph may have been taken, a thousand Border Ruffians from Missouri rode into the free-soil town of Lawrence, Kansas, and destroyed it. In reprisal, Brown and seven Osawatomie men dragged five pro-slavers from their homes at midnight and hacked them to death with broadswords. If blood they wanted, John Brown would see they got it—eye for eye and life for life.

Brown buried one son in Kansas, and in December, 1858, he and his men raided Missouri territory, forcefully liberated eleven Negro slaves, and took them eleven hundred miles to Canada, with the authorities in hot pursuit and a price of $250 on Old Brown's head. The next year he was in Maryland, bearded now, in disguise, renting a farm to use as a base for an attack on Harpers Ferry. For twenty years and more he had thought about what he would do, and his plan was to seize the Federal arsenal at Harpers Ferry, free and arm slaves, and set up a Negro commonwealth in the mountains of Pennsylvania and western Maryland. He and his little band took both arsenal and town by surprise, but there the plan began coming apart at the seams; Brown seemed seized with a curious inertia, and while he waited, perhaps for the slave uprising to begin, government troops under Lieutenant Colonel Robert E. Lee surrounded the enginehouse where he and his followers and their hostages (including George Wash-

ington's great-grandnephew and a sword given to the Father of His Country by Frederick the Great of Prussia) were holed up. Of the twenty-two-man "Army of Liberation," five escaped, ten—among them two of Brown's sons—were killed, and seven were hanged. On December 2, 1859, John Brown went to the gallows, a lesson to any others who might wish to free the black man.

Then there was the other Brown, the other half of the Jekyll-Hyde face: the family man and father who used to hold the children in his arms for hours each evening and sing them his favorite songs; the tender parent who, as one son recalled it, "rose on the coldest night and paced the floor with a collicky child" so his wife could rest. He was a "just and generous man," that son wrote, father and nurse to them all, a man untutored but strangely skilled in medicine, a man whose kindness to animals was legendary. In the Brown household the day was ushered in and out with Scripture and prayer; the family stood in a circle, reading from the Bible in rotation, and for years afterward the children would remember above all else their father's "faith in God, his faith in his family, and his sense of equity." Writing to his wife one time, he hinted at the furies that drove him to leave home and his beloved family: "There is a peculiar music in the world," he said, which one had to go forth to hear; and he begged that her face might shine "even if my own should be dark, & cloudy."

Hating everything that gave one man an advantage over another, John Brown regarded the cause against slavery as one in which "every man, woman, and child of the *entire human family* has a *deep* and *awful* interest." It was his conviction that color has nothing to do with a man's rights —a belief so central to what America is that the nation neglects or forgets it only at its peril.

He was born in 1800, and along the tortuous road to Harpers Ferry John Brown worked at half a dozen occupations before giving all his time to the crusade. His first wife, before she died, bore him seven children, of whom

only two lived to maturity; by his second wife he sired thirteen others. Seven of them died in childhood, two at Harpers Ferry, but no matter how bitter the cup, Brown's faith in God never wavered. After the depression of 1837, his family knew nothing but hard times and sorrow and danger, and they were all prepared for what might happen after John Brown headed for Virginia. He had vowed "Eternal war with slavery," and the road he had to take was clear. "Let our motto still be Action, Action," Brown once said, "as we have but one life to live." He regarded slavery as a state of war in which the slaves were unwilling parties; consequently they had a right to anything necessary to achieve their peace and freedom. He was but an "instrument in the hands of Providence," answering the "cry of distress of the oppressed."

Early in November of 1859, after his capture, Brown wrote a letter to his wife and children, adding, almost as an afterthought: "P.S. Yesterday Nov 2d I was sentenced to be hanged on 2 Decem next. Do not grieve on my account. I am still quite cheerful. Go[d] bless you all Your Ever J Brown." In the last letter he ever sent them, he urged them not to be troubled by his fate; ultimately, he knew, his efforts would result in the "most *glorious success.*" And as he went to the scaffold he handed one of his guards a note, stating his certainty that the "crimes of this *guilty land will* never be purged *away*; but with Blood."

Until John Brown struck at Harpers Ferry, America had managed to contain fairly well the violence seething beneath the surface. Perhaps Brown did no more than trigger a disaster that was coming inevitably. But by touching the profound moral issue that underlay the conflict, Old Brown could not be written off simply as a man of violence. His enemies might kill him, the former slave Frederick Douglass said, but they could not answer him. And when the legions of the North marched off, singing the "John Brown Song," the words spoke not of Old Brown's sword, but of his soul.

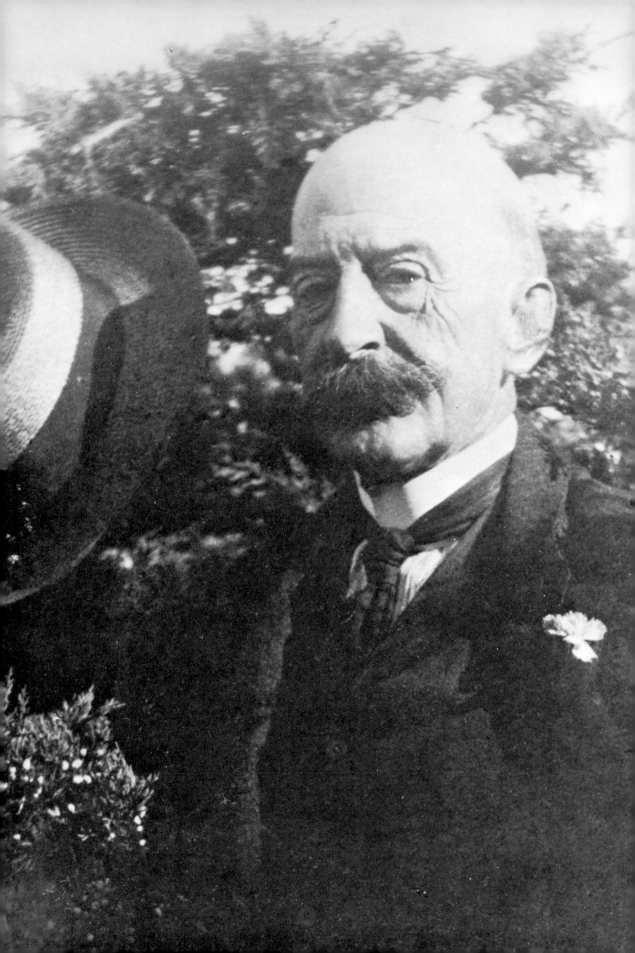

Asmall, dour-looking man with a bushy red Civil War-style mustache, he looked for all the world like a successful and somewhat rakish stockbroker. Reticent, withdrawn, he led a quiet life, and was not one to talk much about himself. In 1908, corresponding with the man who took this photograph, a Boston art critic who wished to write his biography, he said, "It may seem ungrateful to you that after your twenty-five years of . . . booming my pictures I should not agree with you in regard to the proposed sketch of my life. But I think it would probably kill me to have such a thing appear, and, as the most interesting part of my life is of no concern to the public, I must decline to give you any particulars in regard to it." And after that emphatic claim to privacy, there was virtual silence from the isolated studio at Prouts Neck, on the Maine coast, where Winslow Homer had gone to paint and to contemplate the sea in all its moods. "The life that I have chosen," he once wrote his brother, "gives me my full hours of enjoyment for the balance of my life. The Sun will not rise, or set, without my notice and thanks."

His career until then had, indeed, been ordinary enough. Born in Boston in 1836, he had been apprenticed to the Boston lithographer J. H. Bufford; he then became a free-lance illustrator for weekly magazines, and went off to cover the Civil War as an "artist correspondent." After 1865 he spent winters in New York; twice he traveled to Europe; but no painting of a city came from his brush, nor did he follow any school of art.

If he had little to say about himself, Homer, before he became engrossed with the sea, had spoken more eloquently than any artist about a time and scene that have all but vanished. Until the 1880's his work was confined almost exclusively to the New England scene, to the people and way of life he had known and loved from childhood. His strength and vitality seemed to come

from the long summer trips to his northeast homeland, to the White Mountains and the Adirondacks, to Gloucester or the Maine coast. His interest was in people in the landscape—sleigh rides and ocean bathing, husking bees and sailing, picnics, ice-skating, berrying, fishing, hunting —all the simple pleasures of a day that is now part of the national folk memory. What he perceived and painted, simply, clearly, and in all its serenity and beauty, was the afternoon of America.

As the nineteenth century turned slowly into its final quarter, the life most New Englanders knew was that of the small town or farm. The most precious time of year was summer, when the smells, sounds, and silences of nature were all the more acute for being crowded into so brief a span. All the world had an early morning freshness, school was out, and ahead of every child there stretched the limitless vista of summer. Beneath the shading elms and maples of Main Street were white houses in perverse alignment and behind them big, comfortable yards sprinkled with apple trees and honeysuckle, weathered sheds, and squeaky rope swings that lifted a child high above the vegetable patch to command, for an instant, the hills and woods beyond. Out in the meadows, insects droned their course from daisy to black-eyed Susan and boys tramped through tall grass toward still, secret pools where the big trout lay. Here and on the hilltops, where little ginghamed girls swung through forgotten clearings looking for blueberries, only the far-off note of the dinner horn was a link with reality.

This was a world of wagons and green apples, of lemonade in tall, cool, earthenware crocks, of chicken sounds and cowbells, and dogs that wandered into church to scratch and be snickered at. There was time to laze on the warm earth, smelling the grass smell, wondering if a real agate marble was worth the trade of a jackknife with a broken blade or if the blackberry pie was for supper.

Not far from this world, but not for a moment part of

it, were the resorts and hotels, the porticoed watering places of summer people. From all parts of America decorative visitors flocked to the Berkshires, the White Mountains, and to the sandy bluffs of Long Beach, New Jersey. At Newport, charioteers and riders made their dignified rounds of Ocean Drive. Overdressed picnickers picked their way gingerly along the beach, and hoop-skirted young ladies garnished croquet lawns with splashes of color. A few hardier souls chose the wilderness still existing in parts of New England and the Adirondacks, but most settled for places like Saratoga, where a man could tilt his chair back and sit all day on the Grand Union Hotel's endless piazza, watching the parade of parasoled elegance. Between rocker and hammock, the sensible click of knitting needles vied with fancies of Ben-Hur and Marjorie Daw, then faded into thoughts of the evening Masquerade and Promenade Concert.

Just over the horizon of this good, comfortable life was a new century, a turning point; and as the time of their youth slipped by, people began to realize that what they had witnessed was irretrievably gone. Getting on in the world seemed, in America, to mean getting out of a world they had known and loved. There was no going back. But as if to prove that the memories of that other life could be relied upon, Winslow Homer — who had seen these things for what they were — had left us the plain, simple record of those golden days.

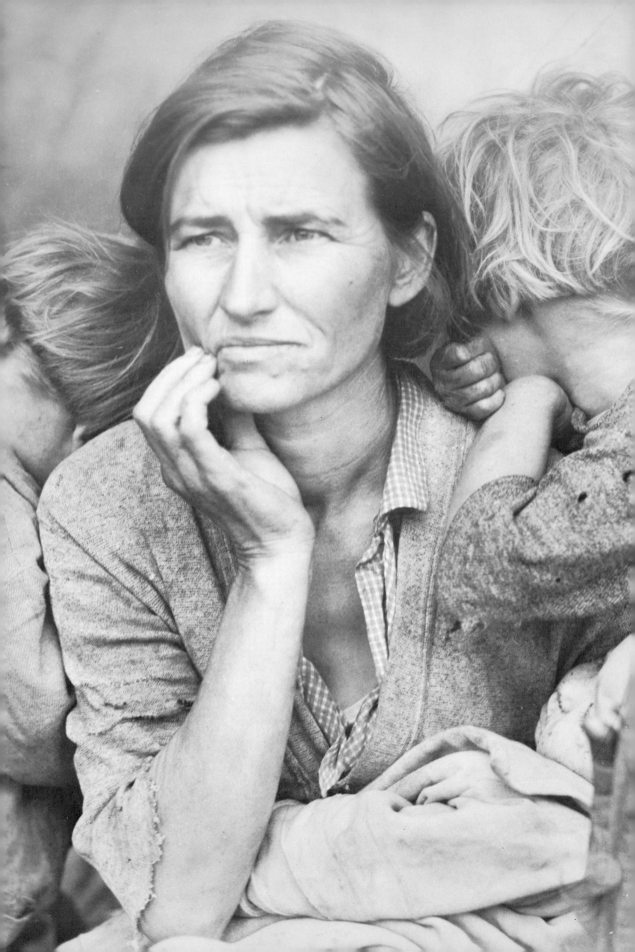

Behind was the road, fifteen hundred miles of concrete stretching eastward to the past. Back home they had had three bitter years, each worse than the one before. All the way from the Dakotas to the Rio Grande, men said, the same wind blew, working away at the dried-out crust of the fields, loosening the dirt, carrying it off in whistling swirls, gathering strength until great brown clouds swooshed off with an angry roar. On Armistice Day in 1933 the sky was dark as far east as Albany, New York, and a red, poker-chip sun hung over the plains. Men and women huddled in their houses, tied handkerchiefs over their noses and mouths when they went outside, and children choked on the dust. When the wind wasn't blowing, the dust lay like fog, sifting down endlessly, piling up on houses and fence posts, smothering what few plants survived.

Always before there had been someplace a man could go when things went wrong—forests unimaginably rich, streams running clear, grass for grazing. And a man who owned an acre of ground could look a stranger in the eye or tell him to go to hell. Now the land was used up; where there had been trees there were millions of stumps, rivers were choked with sewage and trash, and year after year the topsoil blew away on hot summer winds or ran off with the snow and spring floods. Great chunks of the continent had turned to hardpan or dust, and families that once owned the land worked it now for someone they didn't even know. Debt-ridden, their only harvest weeds and misery, they were hated in the towns, where they applied for relief or looked for jobs. Finally there was nothing to do but move.

Leaving home meant weighing the memories of generations, sorting out family belongings, paring them down to what would fit into one crowded vehicle. Farm tools and equipment and animals were sold for next to nothing. All the non-essentials had to go—chest of drawers, stove,

scrapbooks, toys, pillows, old letters, lamps. Next they needed a car, and in every town were hard-eyed, fast-talking men with jalopies for sale at a price. As fast as they could find them, dealers sold the old wrecks, squeezing every penny they could out of the desperate, impoverished men who were departing. When they had gone, nature usurped their homes: birds and bats and field mice moved into the deserted shells, the dust settled permanently on the floor, piling up, covering every trace of the people who had lived there.

Westward they drove, heading for a Promised Land in the tradition of their forebears, jamming Routes 66 and 30 and the old Spanish Trail in dilapidated cars and trucks piled high with people and possessions. Out of Arkansas and Oklahoma went unending streams of them, joined at each new crossroad by more grotesque arks feeding into the main stream of Route 66. Refugees no less than people who flee in the path of a conquering army, they were fugitives in their homeland, running from a nameless force, running because in their own country there was no one who understood them or their problem or wanted to help. On the road they fell into the old ways of pioneers, rolling all day, stopping at night near water, congregating for company and comfort in little groups. At night by the fire, storytellers and guitar players talked and sang until the coals turned white and it was time to bed down for the night. In the morning tents were struck, pots and pans and beds were loaded back onto the cars, and the chuffing, cranky heaps started off again, their drivers solemn-faced, wary, worrying about a weak tire, a noisy valve, wondering if the old wreck would hold together until the next town.

Westward, ever westward they chugged, across the Texas Panhandle, the New Mexico mountains, the Rio Grande, the high mountains of Arizona, over the Colorado, into the terrible desert, mountains again, a pass, then suddenly, the Promised Land—the lush, sun-

warmed valley of California. But where they had hoped to find a new home and a new life they found only thousands of others like themselves, camped in Hoovervilles at the edges of town. Hatred they found, too, hatred born of the fear and contempt that men of property so often have for those who have nothing. Yearning for food and a piece of land, they saw food and land along every road, but none of it for them. Sheriffs and deputies, bully boys with guns and clubs, came to push the squatters out, move them along, "keep 'em in line," calling them commies and dirty reds along with the contemptuous "Okie." Always the children were hungry, dirty, tired, and sick, and still the migrants came by the thousands. There were ten pairs of hands, twenty sometimes, for every job, and men who had learned their farming on the plains found that things were different here: the California ranches were food factories, not farms, and when the peaches were picked, there was no more work on that place until they ripened again, so you had to look for the next crop, move fast to catch another harvest—walnuts, apricots, grapes, celery—whatever it was and wherever you found it. Along the highways were signs: "Cotton Pickers Wanted," "Pea Pickers Wanted," but so many wanted work that the price of labor went lower and lower. Who was fool enough to pay laborers twenty-five cents an hour when hundreds of men stood by, pleading to work for twenty?

All these things and more the woman had seen when Dorothea Lange, the photographer, came upon her at Nipomo. It was March of 1936 and the woman was stranded; the pea crop had frozen, there was no work, and for days she and the children had lived on frozen vegetables from the fields and the few birds they could kill. Now she had sold the tires from the car to buy food. The picture-taking didn't bother her; she seemed to think it might help someone else. Anyhow, it couldn't hurt.

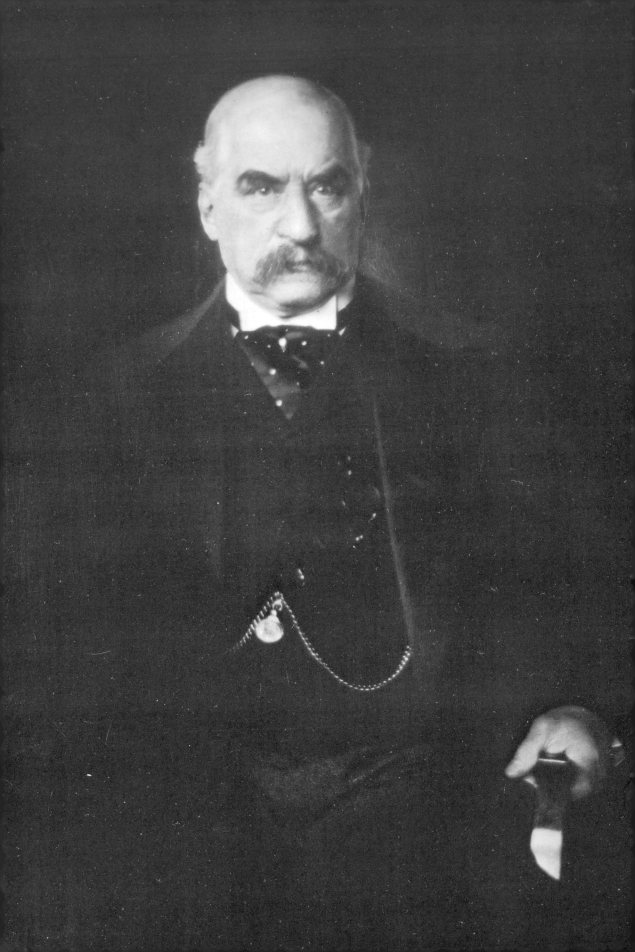

The great man could spare exactly two minutes. Like a huge, baleful dragon he sat, not posing but confronting the camera, defying it to do its worst, gripping the polished arm of the chair so that it looked like a gleaming pigsticker aimed at the vitals. The photographer, Edward Steichen, had time for two exposures; then his visitor rose, clapped a square-topped derby on his head, reached for the big black cigar he had laid aside, and departed.

Afterward Steichen described the impact of that formidable personality: meeting the man's eyes was something like confronting the headlights of an onrushing express train—if you could get out of the way it was only an awe-inspiring experience; otherwise it was calamitous. That was the effect John Pierpont Morgan nearly always had on people. What they saw first was the bulbous, flaming nose that was his affliction and his shame; to avoid staring at it they looked him in the eye and were struck dumb. Lincoln Steffens, who as a young financial reporter had interviewed him, recalled how "his eyes glared, his great red nose seemed to me to flash and darken, flash and darken." That was back in the nineties, a decade before Steichen's great photograph was made, when Morgan was at his office at 23 Wall Street every day. He sat alone, Steffens wrote, in a back room with glass sides; the door was open, as if anyone might walk in and ask a question. But no one dared; not even his partners went near him unless they were summoned, "and then they looked alarmed and darted in like officeboys."

Everything about Morgan bespoke solidity and permanence—his inevitable wing collar, Ascot tie, severe dark suit; the enormous bloodstone that hung from a heavy gold watch chain, the very stone and chain he had worn when he entered the business world in 1857. Everything he did was on a magnificent scale—his yacht, the *Corsair,* was the biggest, the collies he bred won the best blue

ribbons, the works of art he brought back from Europe staggered the imagination. Truly, he was a man above men. As Mr. Dooley put it in an impersonation of Morgan, "call up the Czar an' th' Pope an' th' Sultan an' th' Impror Willum, an' tell thim we won't need their sarvices afther nex' week."

J. P. Morgan was easily the most powerful personal force in American life. In the depression of 1895 he had rescued the United States government (at a price) when it ran short of gold; in 1901 he had put together U.S. Steel, the world's first "billion-dollar" corporation; six years later only his enormous courage, audacity, and prestige saved the country from financial disaster. When he went abroad in 1901 the King of England asked that Morgan be seated at his right at a banquet; in Germany he dined alone with the Kaiser (when Wilhelm II mentioned the subject of socialism, Morgan glared at him momentarily and then announced: "I pay no attention to such theories"). The public image of him was evident in a song of the period, which told of a weary pilgrim seeking a place to rest, only to be turned away again and again with the words: "It's Morgan's, it's Morgan's. . . ." Then, at last,

> *"I went to the only place left for me,*
> *So I boarded a boat for the brimstone sea;*
> *Maybe I'll be allowed to sit*
> *On the griddled floor of the bottomless pit;*
> *But a jeering imp with horns on his face*
> *Cried out as he forked me out of the place:*
> Chorus:
> *It's Morgan's, it's Morgan's; the great financial gorgon's;*
> *Get off that spot, we're keeping it hot;*
> *That seat is reserved for Morgan."*

Inevitably the zealous young President, Theodore Roosevelt, and the crusty old financier ran afoul of one another. In 1902, only five months after Roosevelt took

office, Wall Street shuddered with the news that the government planned to demand dissolution of the Northern Securities Company, the giant holding company created by Morgan and James J. Hill to control the Northern Pacific, the Great Northern, and the Chicago, Burlington & Quincy railroads. At 23 Wall the air was sulphurous; Morgan left immediately for Washington. In a dramatic meeting he criticized the brash young man in the White House for what was clearly a violation of vested rights, took him to task for not warning him of his plans, and concluded with the famous words: "If we have done anything wrong, send your man [meaning the Attorney General of the United States] to my man [a Morgan attorney] and they can fix it up." As the President was quick to see, Morgan regarded him as "a big rival operator"; privately, the banker considered him wildly irresponsible. "The man's a lunatic," he said. "He is worse than a Socialist." Nor was Morgan one to let bygones be bygones. When Roosevelt left the White House and announced his plans to go hunting in Africa, the financier growled, "I hope the first lion he meets does his duty."

Ironically, Morgan's last public appearance was in the nature of an accounting for the power he had wielded. In 1912, a year before he died, he was called to Washington to testify before the so-called Pujo Committee—a House subcommittee determined to prove that Morgan and a small group of New York bankers held the nation's economy in an iron grip. During the course of his testimony, J. P. Morgan revealed the credo which had governed his long career. The attorney conducting the examination asked whether commercial credit was not based primarily upon money or property. No, Morgan replied firmly, "the first thing is character."

"Before money or property?"

"Before money or anything else. Money cannot buy it. . . . Because a man I do not trust could not get money from me on all the bonds in Christendom."

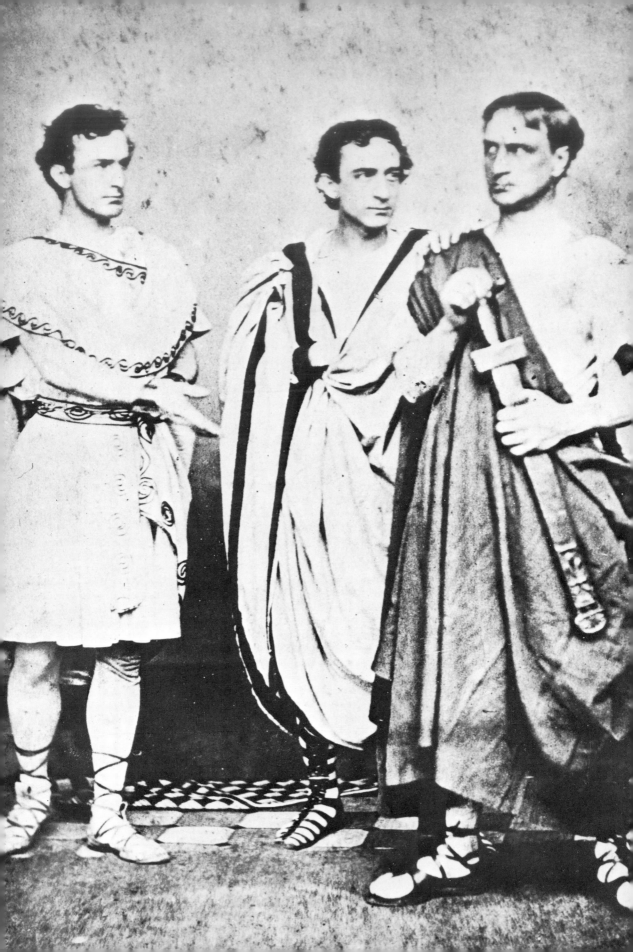

The crowd began collecting early at the Winter Garden. All over the city billboards proclaimed the evening's benefit as one of the great performances of the age, and lower Broadway had a holiday air of excitement. Men were dying in the trenches in Petersburg, Virginia; Sherman's men, in the capital of Georgia, were lighting their campfires with Confederate money; but in New York the three sons of the great Booth were treading the boards together for the first time.

None of his young sons, it was felt, quite equaled Junius Brutus Booth, the magnetic, stumpy-legged tragedian whose name was enough to fill any theater in America even when he was a hopeless drunk, his mind almost gone. When he died in 1852, Rufus Choate, the Boston orator, had exclaimed: "What, Booth dead? Then there are no more actors!" Yet in the twelve ensuing years the tragedian's sons had proved that there was hope for the American theater. Edwin was now the rage of the East; Junius Brutus, Jr., of the West; and John Wilkes the darling of the South; but the performance of *Julius Caesar* on November 25, 1864, at the Winter Garden was the first to join them all on the same stage.

A long roll of applause greeted their entrance with the procession in the first act: in a short toga, curly-haired John Wilkes, his mustache shaved for the part, was a darkly handsome Mark Antony; Edwin, slight in body compared to his two brothers, played Brutus; the stocky Junius, looking for all the world like his father, appeared as Cassius. The audience had just settled down to Act II when noises were heard outside the theater—the sound of fire engines and a crowd—and there was a fleeting moment of panic until Edwin stepped forward and reassured them that there was no cause for alarm. The play went on, and at its conclusion came a thunderous ovation, a succession of curtain calls.

Drifting out of the theater, the crowd learned that the

fire had been one of many in the city that night, all part of a plot by Confederate agents and sympathizers to burn New York. And at breakfast next morning the headlines set off a violent political fight among the Booth brothers — Edwin and Junius strong in their support of the President and the Union, John Wilkes arguing hotly that they would live to see Lincoln king.

The performance of *Julius Caesar* had been their first joint appearance, and it was their last. Less than five months later John Wilkes Booth — driven by a demented desire for fame and a perverted loyalty to the lost Confederate cause — slipped into Ford's Theater in Washington, entered the President's box, and fired a bullet into his brain. He leapt to the stage, breaking a leg as he fell, hobbled out through a stage door, and was swallowed up by the night. Abraham Lincoln was carried across Tenth Street, to die in the back room of a boarding house in the same bed which John Wilkes Booth had occupied two weeks earlier, and after a twelve-day manhunt the assassin was trapped in a barn and shot. Now the skeins of tragedy, as dark and twisted as any Shakespeare contrived, enveloped the entire Booth family.

Edwin swore that he would never appear on the stage again, but in 1866 debts forced him to do so, and the announcement of his return prompted the New York *Herald* to ask if he would play the assassination of Caesar. An ugly mob turned out for his opening in *Hamlet*, but the sight of the humble actor, his head bowed to his chest as if in penance, did something to them, and they cheered him. In March of 1867 the Winter Garden burned, and with it went Edwin's entire professional wardrobe, the most priceless possession an actor had in those days. Soon he was working to build his own theater, a project that consumed every penny he made or could borrow, and in 1869 it opened. His triumph was short-lived; the following year his wife lost a son at birth, and in the panic of 1873 Booth's Theater failed. On the heels of bank-

ruptcy, his wife began to lose her mind.

Tangible memories of the family disaster were forced upon him. For the sake of his aged mother, Edwin tried to reclaim the body of John Wilkes, which had been dumped beneath the stone floor of the arsenal in Washington, and one of Andrew Johnson's last acts as President was to permit the family to exhume and identify the remains and reinter them in the family plot. Edwin felt obliged to reimburse the Virginia farmer for the barn which had been burned at his brother's capture, and once he even had a request for free tickets to a performance from Sergeant Boston Corbett, the man credited with shooting John Wilkes.

The house of his sister Asia became a house of hate; she and her husband were exiles in England, each despising the other for his relationship to the crime, and Asia, like another sister Rosalie, finally died of melancholia. Junius fell on hard times in the theater and retired to the hotel business; his son, Junius III, lost his mind and committed suicide after killing his wife. The fiancé of Edwin's daughter Edwina went insane just before they were to be married, and the actor's wife died a raving maniac.

At the end only Edwin and a brother, Joseph, remained of Junius Brutus Booth's ten children. Edwin was not yet sixty when he died, but his face and figure were those of an old, old man, weary of "this hell of misery to which we have been doomed," looking forward to death as "the greatest boon the Almighty has granted us." It came, at last, in 1893, but there was one final scene to be played out. Ford's Theater in Washington, confiscated after Lincoln's assassination, had been converted into a government office building. On the same day, at almost the same hour that Edwin Booth's coffin was being carried from the church in New York to the "Dead March" from *Saul*, three floors of Ford's Theater collapsed, killing more than twenty people.

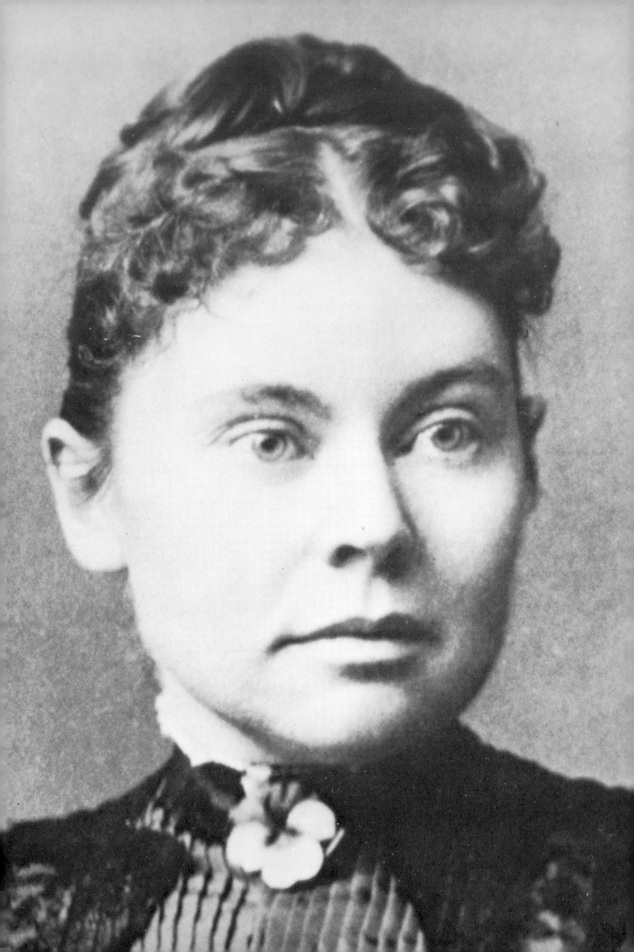

More than three-quarters of a century after the murders, doubt persists, and if you were to ask, "Was she guilty?" the chances are a good twenty-to-one that the answer would be affirmative. The law may protect a defendant from double jeopardy, but it cannot prevent the public from passing judgment.

What might be called the public's "case" against the rather plain young woman began long before the Commonwealth of Massachusetts brought her to trial. It commenced, in fact, the day after the bodies of her father and stepmother were found. Rumor and half-truth spread like wildfire, feeding on the smouldering flames of fear, creating almost overnight a legend that has never disappeared. The story, as it began to build during those first hours, went something like this: On the hot, humid morning of August 4, 1892, in an angular frame house on Second Street, in Fall River, Massachusetts, Mrs. Andrew Borden was brutally hacked to death by someone wielding a hatchet or an axe. Somewhat later, in another room of the house, her husband was similarly dispatched. The news that a respectable couple had been murdered in their own home in broad daylight brought the town's normal activities to a standstill; two hours after the crime was discovered, thousands of hot, angry people were milling about in Second Street, muttering, questioning, venturing opinions, wondering where the mad killer would strike next, who the next victim would be. Before nightfall the town's newspapers had taken over the case, describing the murder scenes in all their gory detail and hinting broadly at suspects.

Now, almost any news about Andrew Borden would have been enough to make the mill town sit up and take notice; he was a silent, sour man who had made money as an undertaker and as exclusive agent for Crane's Patent Casket Burial Cases, who was now an extremely well-to-do banker and real estate owner. It was common gossip

that neither of his daughters, Emma or Lizzie, got on well with their stepmother, whom Borden had married twenty-seven years earlier. But Emma, it seemed, was out of town when the murders were committed. Lizzie had found her father's body on the sitting-room couch and sent the hired girl, Bridget, for help; a little later Bridget and a neighbor discovered Mrs. Borden in the upstairs guest room, lying face down in a pool of blood. So suspicion soon fastened upon the thirty-two-year-old Lizzie, a slight, ordinary-looking girl with brown hair and a habit of saying just what was in her mind.

First Lizzie had killed her stepmother, townsfolk said; then, after cleaning her hands and clothes, she had busied herself about the house for an hour and a half, sewing, ironing, reading a magazine, waiting for her father to return from downtown. After he came in, stretched out on the couch, and dozed off, she attacked him with the same weapon she had used on Mrs. Borden. Again she removed the blood from her clothes and from the axe (all within the space of ten minutes, and so effectively that later chemical tests revealed no trace of it), then called for help. Someone said she never shed a tear when the bodies were discovered; the maid Bridget was said to have heard her laugh coldly when her father entered the house; there was talk that she had tried to buy poison the day before the murders; someone said she was seen burning a dress afterward.

Five days after the crime an inquest was held; two days later Lizzie Borden was arrested and held without bail pending trial. Meanwhile the wildest theories and rumors gained currency. But most damning of all was the verse — those unforgettable four lines of doggerel, sung to the tune of "Ta-ra-ra-boom-de-ay," which condemned her forever in the public mind, no matter what any court might decide:

> *Lizzie Borden took an axe*
> *And gave her mother forty whacks;*

When she saw what she had done
She gave her father forty-one.

In June, 1893, the trial opened in New Bedford, and for thirteen days the jury heard a great deal of conflicting testimony (much of it highly embarrassing to the prosecution), and witnessed a brilliant performance by the defense attorney. One of the most telling accusations made by the prosecution was that Lizzie had not been in the barn behind the house between 11:00 and 11:15 on the fatal morning, as she claimed—that she had, in fact, been bludgeoning her father to death at that very moment. A sensation of the trial was a surprise witness for the defense, an ice-cream peddler who maintained stoutly and credibly that he had seen a woman, dressed as Lizzie purportedly was, emerging from the barn just when she said she had.

When the trial ended, the jurors were out for a little more than an hour before bringing in a verdict of "Not Guilty." Spectators in the courtroom applauded, and an editorial writer for the New York *Sun* summed up the trial: "A chain of circumstantial evidence is strong only if it is strong in every necessary link. . . . The chain tested at New Bedford the past twelve days was proved fragile indeed, not merely at one place, but in almost every link."

Legally, the defendant was acquitted. Theoretically, her ordeal was over. But the public considered her guilty —guilty by innuendo, if nothing else. Not even her death in 1927 ended the trial of Lizzie Borden. Books and plays were written about her, eventually there were movies, a television show, a ballet. Finally, Edward D. Radin came to her defense with a fine book, *Lizzie Borden: The Untold Story,* that argues her innocence convincingly while revealing the falsehoods behind the legend. There the matter might rest at last, were it not for the cruel verse: "Lizzie Borden took an axe, and gave her mother forty whacks. . . ."

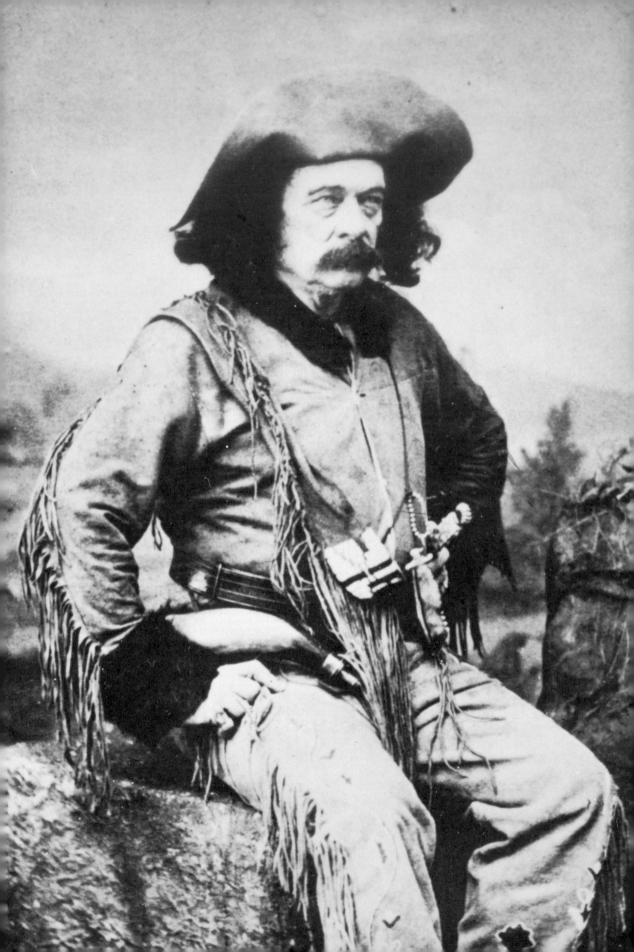

O n the whole," wrote the drama critic of the Chicago *Times* of the show that opened on December 16, 1872, "it is not probable that Chicago will ever look upon the like again. Such a combination of incongruous drama, execrable acting, renowned performers, mixed audience, intolerable stench, scalping, blood and thunder, is not likely to be vouchsafed to a city for a second time,—even Chicago." The play, *The Scouts of the Plains*, had as its principals "Buffalo Bill" Cody and "Texas Jack" Omohundro (a former scout with Jeb Stuart's cavalry), both playing themselves; Mlle. Morlacchi, acting the part of Dove Eye (she was described by the *Tribune*'s critic as "a beautiful Indian maiden with an Italian accent and a weakness for scouts"); numerous supers as Indian warriors; and the man known as Ned Buntline, in whose wildly fertile imagination the spectacle had originated, playing the hero, Cale Durg. (He is posing, opposite, in costume for that role.) In city after city in which the troupe performed, critics carped. The New York *Herald* said that Buntline played the part of Cale Durg "as badly as is possible for any human being to represent it," and took particular exception to the scene in which Durg, momentarily subdued by redskins, was tied to a tree with a torture fire ignited at his feet, from which position he delivered a long temperance lecture. But with the public, Ned Buntline had scored again.

Born in 1823 as Edward Zane Carroll Judson (on a night, he later wrote, "when thunder loudly booming/ Shook the roof above my head—/When red lightning lit the glooming/Which o'er land and sea was spread"), he ran away to sea when he was eleven, embarking upon a career in which fact and fiction became so thoroughly entangled as to defy separation. By the time he was twenty he had fought in the Seminole War, taken his first wife, and published his first story—under the pseudonym Ned Buntline (a buntline being a rope at the bottom of a

square sail). Before long he had, by his own account, traveled to the Far West and killed buffaloes and grizzlies; started a periodical called *Ned Buntline's Own*; and been lynched in Nashville, Tennessee. There, shortly after his wife died, Ned had made no secret of his admiration for young Mrs. Robert Porterfield, and one day her husband came looking for him. Porterfield fired at Buntline, who took aim and shot his pursuer through the head. Ned was in court pleading self-defense when Porterfield's brother and some friends poured in and started shooting. After a wild chase, during which Ned was hit in the chest by one bullet, he fell forty-seven feet from a window (the injury left him with a limp for life) and was captured by the sheriff's men. That night a mob stormed the jail, dragged him from his cell, and strung him up by the neck from a post on Public Square. But Ned had one of those miraculous escapes so familiar to readers of the stories he would write: three weeks later a letter from his cell reported that he would be leaving soon; after complaining of the gross injustice done him, he noted that the "rope didn't break, it was cut by a friend."

Back in the East, he resumed publication of *Ned Buntline's Own,* began cranking out paperback books that sold for ten cents (dime novels, people called them), and embarked upon a social reform series entitled *The Mysteries and Miseries of New York.* It was "drawn from *life,*" he wrote, "heart-sickening, *too-real* life"—a life full of clerks who had embezzled money to pay their debts, only to find themselves in the toils of gamblers; of proud but poor sewing girls, fighting off tuberculosis and libertines ("By Jove, I'll have a kiss if I die for it!" "Wretch! Fiend! *dog!* Back, sir! stand back, if you value your life!"). And so on, from one insoluble dilemma to another, with hero and heroine on the brink of destruction or ruin or both at the end of each installment. *The Mysteries and Miseries* sold over 100,000 copies, and reprints and translations made Ned Buntline a sub-literary figure of world renown.

Married again now, he explained to his latest bride that he kept a sword, pistols, and a dagger in his study because his life was in constant danger from the villains he was exposing.

Between stories and issues of *Ned Buntline's Own*, he found time to get into an unending variety of scrapes and scandals. Once, while out of jail on bond pending trial in a riot case, he was served with summonses in a slander suit and a divorce, and was arrested for debt. He became involved in spiritualism, labored mightily for the Know-Nothing party, organized a concert troupe, was arrested in St. Louis for leading a riot, gave temperance lectures (many of them while drunk), shot at least one man, and married several women (at least two concurrently), was jailed for bigamy, served in the Civil War (he later claimed that he was a "chief of scouts with the rank of colonel"), and produced an endless number of books—*The Boot-Maker of Fifth Avenue, or, A Fortune from Petroleum; Merciless Ben, the Hair Lifter; Quaker Saul, the Idiot Spy, or, Luliona, the Seminole: A Tale of Love, Strife & Chivalry; Thayendanegea, the Scourge, or, the War-Eagle of the Mohawks: A Tale of Mystery, Ruth, and Wrong;* and so on, and on. "If a book does not suit me when I have finished with it," he said, "I throw it into the fire and begin all over again."

In 1869, while on a trip to the West, Ned Buntline met the tall, good-looking plainsman named William Cody, and it was only a matter of months before Cody had become "Buffalo Bill, The King of Border Men," hero of a new Buntline series. Then Ned persuaded Cody to join him in Chicago to perform in *The Scouts of the Plains*. Ned took just four hours to write the play, rehearsed it twice, and it ran for more than two years—two years during which Buffalo Bill became a national hero, symbol of all that was bravest and best on the frontier. Ned Buntline live on until 1886, turning out stories until the last, but of all his characters, only the greatest—Buffalo Bill—survived him for long.

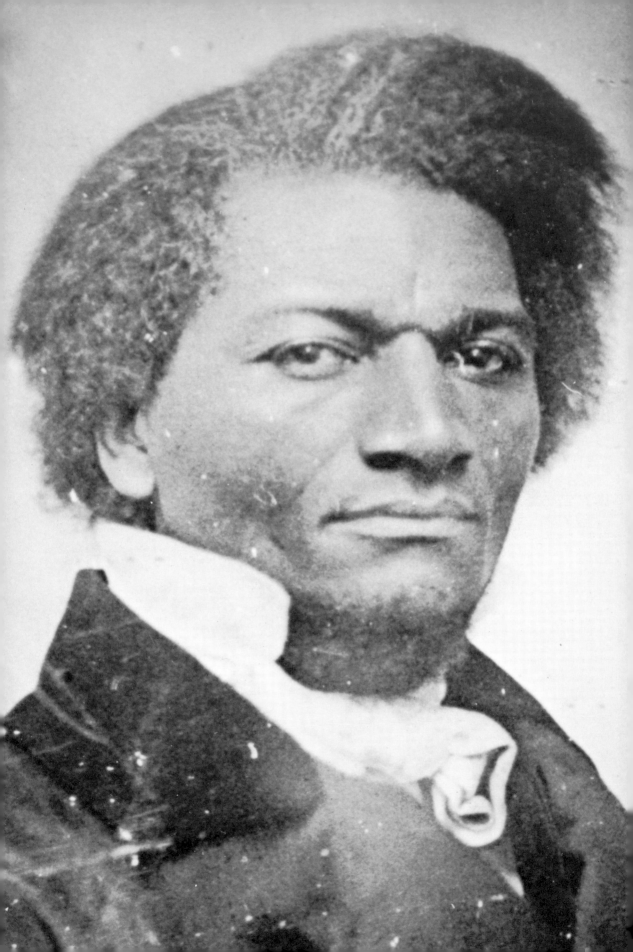

By the 1840's a shrill handful of abolitionists had kindled a spark that would burst into civil war a generation later and continue to flare up, crackling at the surface of American life until the white finally accepted the fact that the Negro, despite the color of his skin, was equally a man.

The slaveholders, threatened, retaliated with a defense of their system. Allusions were made to its divine origin and sanction; the argument was advanced that the naturally inferior blacks were better off under some form of benign bondage—better housed and fed, more secure, and less exploited than northern factory workers. It was one of those odd accidents of history that at the very time this southern propaganda was gathering momentum, an extraordinary individual came to the attention of the abolitionists—a man described by one of them as a recent "graduate from the 'peculiar institution' with his diploma written on his back." He called himself Frederick Douglass, but he had been born Frederick Augustus Washington Bailey, the son of an unknown white father and a slave woman named Harriet Bailey. Twenty-one years he spent as a slave—years during which he saw men and women of his race lashed and beaten, chained together like animals in slave pens, families separated, children taken from their mothers, women locked up with male slaves for breeding purposes. He got into trouble for refusing to call his owner Master and for teaching a Sunday school class for Negro children; so he was turned over to a professional slavebreaker who overworked him, whipped him daily, starved and humiliated him. Deciding that death could be no worse, Douglass turned on the white man and fought him. "This battle," he said later, "was the turning-point in my career. . . . I was nothing before, I was a man now."

In another way he triumphed over the system. He had an insatiable desire for learning, realizing that it was the "pathway from slavery to freedom," and at the age of eight he begged his mistress to teach him letters and

words, which she did until her angry husband discovered what was happening ("Learning," he told her, "would *spoil* the best nigger in the world.") So Frederick persuaded white boys in the neighborhood to teach him a word here, a word there, which he practiced writing on a board fence; with his first pitiful savings he bought *The Columbian Orator* and read the impassioned speeches of Chatham and Fox in support of human rights.

In 1838 he escaped, made his way to New Bedford, Massachusetts, married a free Negro, and discovered William Lloyd Garrison's newspaper, *The Liberator*, which became for him "my meat and my drink. My soul was set all on fire." Three years later, after meeting Garrison for the first time, he was asked to speak at a meeting and describe his life as a slave. From that moment, his mission and his career became one, for as an abolitionist wrote, "The public have itching ears to hear a colored man speak, and particularly *a slave*." Douglass had a profound effect on audiences: what he told them was startling enough; but he was also physically commanding, over six feet tall, with brown skin and a great leonine head of hair, a fine voice, and flashing wit. "He was cut out for a hero," one man said. A reporter hearing him for the first time was struck by the way "he stalked to and fro on the platform, roused up like the Numidian lion. . . . He reminded me of Toussaint among the plantations of Haiti. There was a great oratory in his speech, but more of dignity and earnestness than what we call eloquence. . . ."

At first he told only of his experiences as a slave; then he widened the theme to attack prejudice in the North. "You degrade us and then ask why we are degraded," he cried, "you shut our mouths, and then ask why we don't speak — you close your colleges and seminaries against us, and then ask why we don't know more." In 1845 he published the *Narrative of the Life of Frederick Douglass*, an eloquent little book that increased his fame at home and abroad. That year he went to the British Isles and enjoyed

immense success, lecturing that slavery was not America's problem alone, but that of all mankind. A result of the trip was that his English friends raised seven hundred dollars to purchase his freedom from his former master.

Home again, he launched an antislavery newspaper, *The North Star*, and by the time the Civil War began, when he had become the leading figure in the antislavery movement, Douglass was boldly advocating two ideas that Lincoln eventually adopted: freeing the slaves as an act of war and recruiting blacks into the Union Army as a symbol of the Negro's citizenship. When the war was over, Douglass was concerned that the former slaves "are becoming a nation in a nation which disowns them," and he hammered away at the theme that white and black had to live and work together as equals. Slavery, he knew, would not end in fact until the black man had the ballot. "Without this," he cautioned, "his liberty is a mockery." And as for the argument that he was not ready for the vote: "As one learns how to swim by swimming, the Negro must learn how to vote by voting." In a major address on the anniversary of the Emancipation Proclamation, when he was a United States Marshal in the District of Columbia, Douglass protested that the government had abandoned the black man, leaving him "a deserted, a defrauded, a swindled, and an outcast man—in law, free; in fact, a slave."

After his wife died he married a white woman, and in response to the inevitable attacks he remarked that this only proved his impartiality: his first wife had been the color of his mother; his second was the color of his father. His whole life, he said, had been devoted to attacking the system that reduced *man*—not the Negro—to the condition of an animal: "I . . . plead no man's rights because of his color." And in 1895, the year he died, Frederick Douglass gave a young Negro seeking advice a message for the future—"Agitate! Agitate! Agitate!" Those who did not believe in agitation, he said, "are men who want crops without plowing up the ground."

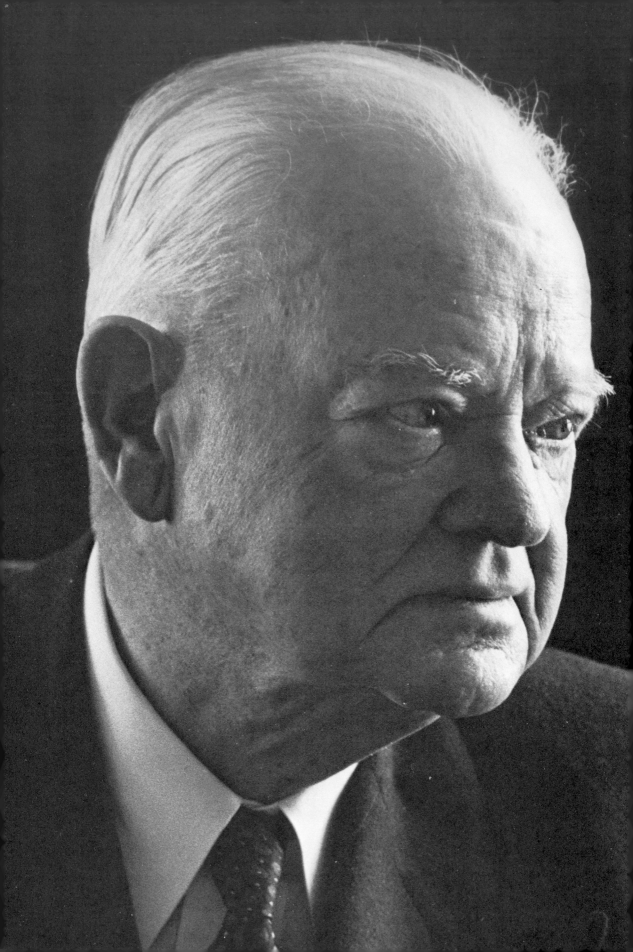

The old man was one of the last direct ties to a past Americans did not want to lose—a throwback to the days of pioneering, of covered wagons and homesteads, of simple moral values and deeply held religious convictions. He had a sense of history himself, an awareness of the continuity of human affairs; as Chief Executive of the nation he once observed that "No man can be President without looking back upon the effort given to the country by the thirty Presidents who in my case have preceded me. No man of imagination can be President without thinking of what shall be the course of his country under the thirty more Presidents who will follow him. He must think of himself as a link in the long chain of his country's destiny, past and future."

Herbert Hoover's own destiny had begun in West Branch, Iowa, in 1874. Only six years later his father, a blacksmith, died of typhoid fever, and when he was eight his mother succumbed to pneumonia. At the age of ten, Bert, as he was called, left for Oregon to live with relatives. His only material assets, he recalled, were two dimes, the suit of clothes he was wearing, and some extra underwear; but he took with him several intangible possessions: an appreciation for learning, a family tradition of hard work, a "stern grounding of religious faith," and recollections of a joyous childhood. Those things remained with him always. So, indeed, did the scar left by his parents' deaths. Seventy-five years later, when a reporter asked his opinion of the greatest change in human existence during his lifetime, he spoke eloquently about the advances in public health and medical science. People no longer died so often in the prime of life, he said, remembering the hillside overlooking West Branch, where his mother and father were buried.

After college he worked for awhile in a mine—ten hours a night, seven nights a week, for two dollars a day. Later, as an engineer, he went out to Australia, to China,

to dozens of other countries, traveling incessantly, organizing and promoting mining companies, becoming, finally, a wealthy man. At the outset of World War I he was in London, and because of his organizing talent was asked to take on a succession of humanitarian jobs, among them the administration of Belgian relief. In the starvation days that followed the war, he fed countless millions of people, friends and former enemies alike, in twenty-three countries. By the time he returned to the United States in 1919 he was an internationally known figure. When the Assistant Secretary of the Navy, Franklin D. Roosevelt, talked with him for the first time he thought him "a wonder." Roosevelt added, "I wish we could make him President of the United States. There could not be a better one." Nine years later, after he had served as Secretary of Commerce under Harding and Coolidge, Herbert Hoover got the opportunity to prove that Roosevelt was right. The son of the West Branch blacksmith became the thirty-first President.

If ever there was an object lesson in the relationship of luck and timing to history, surely it was the case of Herbert Hoover. Even John Nance Garner, who as Democratic Speaker of the House often stood in the way of Hoover's emergency proposals between 1931 and 1933, admitted: "If he had become President in 1921 or 1937 he might have ranked with the great Presidents." Instead, eight months after his inauguration, through no fault of Hoover's, the stock market crashed and the whirlwind of economic chaos swept across America. It was his misfortune to be struck down by catastrophe, and although he never relaxed his efforts to hold back the tide of disaster until the moment he left the White House, only a decade after his humanitarian triumphs he had become the butt of a thousand bitter jokes, his name a prefix of hate. The man who had fed Europe became a symbol of hunger in his native land. And six years after he left office, when there were still nine million Americans out of

work despite all the New Deal had tried, Herbert Hoover continued to get the blame.

As the years passed, the public attitude toward him mellowed, in much the same manner that his stiff, round collar gave way to a softer one. Fortunately, he lived long enough for his countrymen to discover him as a person, to find the quiet kindliness, the courtliness, the old-fashioned decencies, and the humor he possessed. Long after the time most men retire, he continued to labor in the public interest ("Being a politician," he said, "is a poor profession. Being a public servant is a noble one"). And until the last months of his life he worked ten hours a day, keeping seven secretaries busy, writing books and maintaining a voluminous correspondence—much of it with children, whom he considered "our most valuable natural resource." For three decades he served the Boys' Clubs of America as an active chairman. Answering the thousands of letters from young people, he observed, was "a great relief from sleepless nights haunted by public anxieties." His advice to them was simple and direct, as he was: to one he wrote, "Do not neglect being just a boy. It only comes once." And he enjoyed telling of the time he received a request for three autographs: when he made the mistake of inquiring why, the answer came back, "It takes two of yours to get one of Babe Ruth's."

Most of all he liked to talk about the legacy of freedom and the precious opportunities it provides; he advised his fellow countrymen always to test every legislative act and every social and economic proposal to see if they limited in any way men's energies and their creative spirit. "My story," he told a young admirer, "is only a story of the chance in life which America brings to all boys and girls."

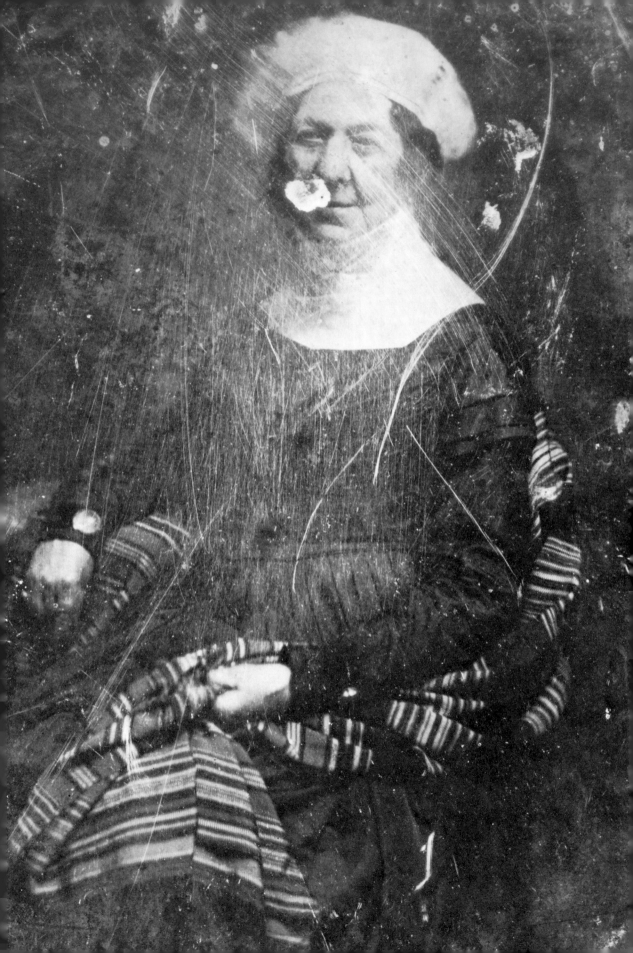

Because the first daguerreotype in this country was made in 1839, it is nearly impossible to bridge, through photography, the gulf that separates us from the eighteenth and early nineteenth centuries. For that reason, the cruelly scarred picture on the facing page is an extraordinary document; it is the photographic likeness of a woman born seven years before the Revolution began, who was an eyewitness to the beginnings of the United States of America, and who was friend to most of the chief participants in those great events. This daguerreotype, made in the late 1840's, is of Dolley Madison, wife of the fourth President of the United States.

It was taken near the end of her life, when she was, in the words of a contemporary, ". . . widowed, poor and without prestige of station [but] the same good-natured, kind-hearted, considerate, stately person, that she had been in the hey-day of her fortunes. Many of her minor habits, formed in early life, continued upon her in old age and poverty. Her manner was urbane, gracious, with an almost imperceptible touch of Quakerism. She continued to the last to wear around her shoulders a magnificent shawl of a green color. She always wore a lofty turban and took snuff."

Before James Madison died in 1836, financial ruin had overtaken him as it had his fellow Virginia planters, Jefferson and Monroe, and his wife inherited a debt-ridden estate and the task of publishing his papers. It was her second widowhood, for she had lost her first husband, John Todd, Jr., and an infant son to yellow fever in 1793. Her only remaining child—a son by Todd—was a spendthrift and gambler, an alcoholic ne'er-do-well for whose sake she sold Madison's plantation, Montpelier, and mortgaged her own house on Lafayette Square in Washington. As Dolley Madison's time ran out, life did not seem to hold much for her. But the wise old eyes of the picture still twinkle, and in her eighth decade she was still very close

to the center of things in the nation's capital.

She became a public figure when Jefferson appointed James Madison Secretary of State in 1801. Jefferson was a widower, and his married daughters came to Washington infrequently; Aaron Burr, the Vice President, had also lost his wife; so the wife of the Secretary of State, who was next in line of precedence, became Jefferson's hostess and social leader of the new capital. When the Madisons arrived there, it was "*new country,*" in Abigail Adams' words, "surrounded with forest," and the President's house (in which the Madisons resided until they could find suitable lodgings) a "great castle" amid the lonely wilderness. But Dolley Madison soon gave the raw capital a standard of manners and a style it badly needed. "She has much taste," the artist Eastman Johnson wrote. "She talks a great deal and in such quick, beautiful tones. So polished and elegant are her manners that it is a pleasure to be in her company." At the inaugural ball held at Mr. Long's Hotel after Madison succeeded Jefferson as President, she was "almost pressed to death" by those seeking a glimpse of her. "She looked a queen," one woman wrote; "It would be *absolutely impossible* for anyone to behave with more perfect propriety than she did."

"Mrs. Madison's levees" were the supreme occasions of the Washington scene. Washington Irving told of entering "the blazing splendor" of her drawing room, where he was graciously received by Dolley—"a fine, portly, buxom dame, who has a smile and a pleasant word for everybody." Under her eye the President's mansion was furnished and decorated (Jefferson had been obliged to bring furniture from Monticello to the empty house), but her efforts went up in smoke in 1814, when the British burned the building. Happily for posterity, Dolley remained there until the last possible moment, packing a wagon with the "most valuable portable articles"—including Gilbert Stuart's portrait of Washington, her husband's papers, and many state documents.

At the end of his second term Madison retired to Montpelier, where Dolley worked with him on his papers and entertained a constant flow of guests, most of them uninvited. When she returned to Washington after her husband's death, one of her first callers was John Quincy Adams. He had not seen her for twenty-eight years and was surprised to find that "the depredations of time are not so perceptible in her personal appearance as might be expected." Following a custom she had begun in the White House, she opened her home to guests every New Year's Day and July 4, and that first winter after her return she paid over two hundred calls herself. Daniel Webster lived nearby on Lafayette Square and was a frequent visitor (after he discovered her financial plight, the Senator often sent a Negro servant around to her door with a basket of food). President Tyler's daughter-in-law regularly sought Mrs. Madison's advice in social matters, and the old lady had a seat in the Tyler carriage on most official occasions. She was with the party in the Capitol when Samuel F. B. Morse, demonstrating his new telegraphic device, received the historic message from Baltimore, "What hath God wrought," and it was to Dolley that Morse turned, asking if she would like to send a reply. She dictated: "Message from Mrs. Madison. She sends her love to Mrs. Wethered" (a friend with the group in Baltimore). Fittingly, it was the first social message sent by telegraph. At the age of eighty, she attended President Polk's final gala ball, walking through the crowded White House rooms on his arm, wearing a white satin gown and the inevitable turban, white satin with a fringe. And when the cornerstone of the Washington Monument was laid, on July 4, 1848, Dolley Madison, who had known George Washington, was there. The cameraman Mathew Brady had gone to the capital to photograph the historic event, and it is probable that he took advantage of the occasion to ask the old lady if she would sit before his camera.

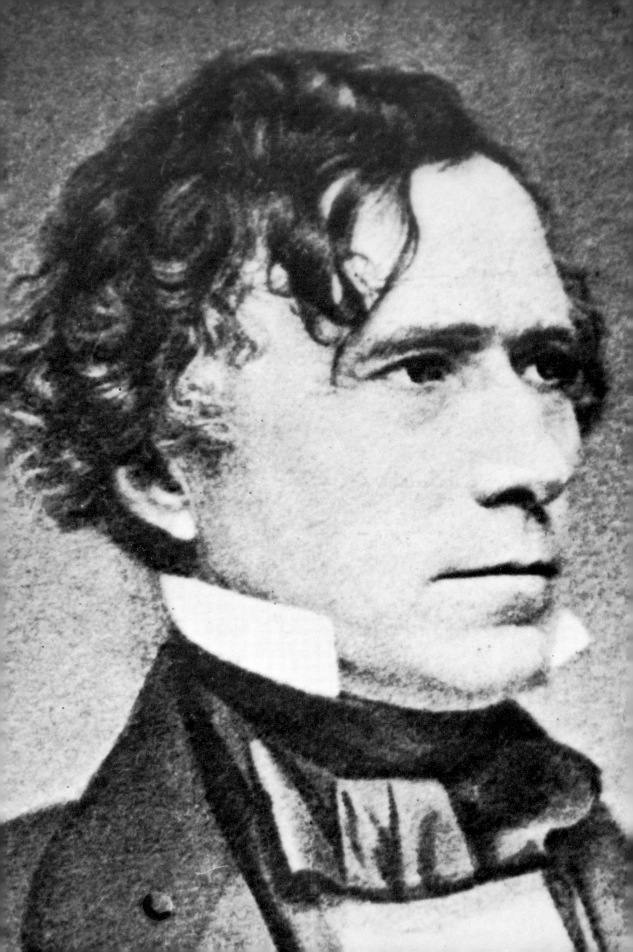

He is the President no one knows. If school children remember him at all, it is as a name that comes somewhere between the Mexican War and the Civil War—and that judgment is strangely close to the heart of the matter. The generation of Webster, Calhoun, and Clay was gone by 1852. In Baltimore, where the divided Democrats were meeting to select a presidential candidate, forty-eight ballots failed to produce a two-thirds vote for any of the contenders. Then, on the forty-ninth, the delegates gave the nomination to Franklin Pierce of New Hampshire, whose only virtue seemed to be that no one hated him enough to keep it from him. He was safe, and safe was what a man had to be in Baltimore in 1852.

On the advice of older, wiser politicians, the candidate did as little as possible and said almost nothing during his campaign against General Winfield Scott. The Whigs called him coward, a drunkard, and an anti-Catholic, and there was some substance behind each ugly charge; but when the ballots were counted, Franklin Pierce had 214,000 more than Scott, 254 electoral votes against 42, and that was all that mattered—or so it seemed.

His program, he said, would be to provide territorial and commercial expansion (which would please the radicals) and to preserve the Union (which would keep the conservatives happy). Pierce considered it a safe, sound policy, and if the year had not been 1853 it might have been. But just then it was perhaps the most difficult and dangerous course he could have steered.

In an effort to achieve harmony, he gave representation in his cabinet to every faction in the Democratic party, thereby ensuring trouble under the best of circumstances. Only there were to be no best of circumstances, but instead a violent eruption of national emotions. The Administration's Kansas-Nebraska Bill resulted in Bloody Kansas; the anti-foreign, anti-Catholic movement took dark shape in the Know-Nothings; westward expansion

and industrialization were shaking the uneasy balance which had existed between North and South, and southerners saw the handwriting on the wall. The times demanded daring and ingenuity and brilliance, but Pierce had none of them; nor did he comprehend the irresistible tide of forces he was attempting to stem. So at the end of four years, with the nation rushing toward disaster, the Democrats took the unparalleled course of turning their own man out and selecting another who appeared to be safer even than Pierce had seemed in 1852—James Buchanan. And Franklin Pierce, fourteenth President of the United States, disappeared from the stage of history as ignominiously as he had entered upon it.

But there is more to his story than posterity has cared to remember, and much of it is revealed in the photograph Mathew Brady took at the time of his inauguration. This is not the proud, determined look of an incoming President; it is the haunted expression of a man drained of vitality, unaware of the camera, whose deeply troubled eyes search the distance as if seeking some answer to his questions.

The first years of his life had been good ones, and Franklin Pierce emerged from New Hampshire politics to become a United States congressman and senator. Then fortune turned against him. His first son lived only three days; his second died at the age of four. His wife, a melancholy, deeply religious invalid, hated Washington, partly because of the climate, mostly because of the alcoholic temptations to which politics subjected her weak husband. Against her wishes he had gone to Mexico as a political general, and there fate gave him three opportunities for glory. The first time in action his horse shied, the pommel hit Pierce in the groin, and he fainted; the next day, advancing with his troops, he twisted a knee and fainted again; and at the storming of Chapultepec, where he had his last chance, he was in bed with diarrhea.

Five years later fortune beckoned once more, this time with the incredible offer of the nation's highest office, which Pierce saw largely as an opportunity to build a heritage for eleven-year-old Bennie, his surviving son. (When he heard the news of his father's nomination, Bennie wrote his mother: "I hope he won't be elected for I should not like to be at Washington and I know you would not either.")

Early in January, 1853, two months before the inauguration, the Pierces were riding the morning train to Concord. A mile out of Boston it was suddenly derailed; their car teetered over an embankment and rolled into the field below. Neither the President-elect nor his wife was injured, but Bennie, the one absorbing interest of their lives, was caught in the wreckage and horribly killed before their eyes.

From that moment on the prospect of the Presidency became a nightmare. From the twisted depths of her Calvinistic conscience, Mrs. Pierce fashioned the idea that her husband's great honor had been purchased by the sacrifice of their son. With this shattering accusation of guilt added to the unimaginable horror of the boy's death, Franklin Pierce went to Washington, alone, to lead the United States in its hour of need.

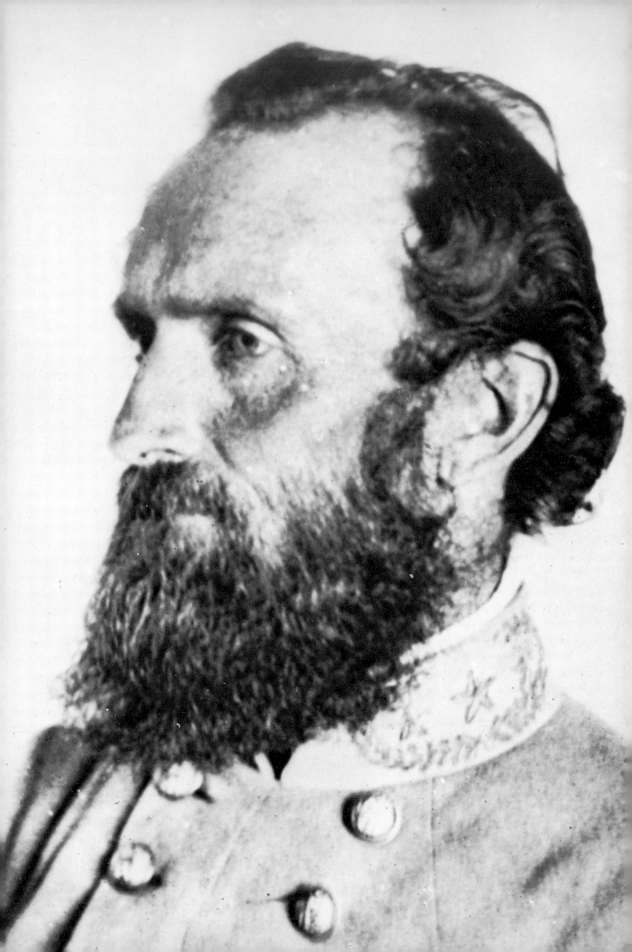

His men had a saying that he always marched at dawn—except when he started the night before. "All Old Jackson gave us," one of them stated, "was a musket, a hundred rounds, and a gum blanket, and he druv us like hell." Drive them he did, with the result that Thomas Jonathan Jackson and his "foot cavalry" came to typify the difference that existed for so long between Confederate and Union forces—a difference that gave the South an edge to compensate for inferior numbers and supply. Jackson, perhaps more than any other of Lee's lieutenants, was capable of pushing his men relentlessly—beyond endurance sometimes—and of pursuing the enemy long after another general would have called it quits. As a Confederate veteran remarked, "A man less open to the conviction that he was beaten could not be imagined."

Born in Clarksburg, then a backwoods hamlet in Virginia, Jackson was orphaned at the age of seven and was raised by an uncle; after working for a time as county constable, he won a commission to the military academy at West Point. Other cadets remarked his doggedness, his extraordinary powers of concentration: "He learned slowly," it was said, "but what he got into his head he never forgot." After graduation he served with distinction in the Mexican War; then he accepted a post as Professor of Artillery Tactics and Natural Philosophy at Virginia Military Institute in Lexington. Silent, dour, unbending, he was no favorite with the cadets, but for ten years he thrust learning at them while, in his free hours, he prayed to John Calvin's wrathful God, studied Napoleon's campaigns, and concentrated on intellectual problems by staring for hours at a blank wall. In April of 1861, after taking his cadets to divine services, Jackson led them to Richmond to join the Confederate Army.

In July of that year, at Bull Run, his brigade came up in support of General Barnard Bee's hard-pressed troops,

and Bee, to stiffen his men, shouted: "Look! There is Jackson standing like a stone wall! Rally behind the Virginians!" One of the enduring names of the Civil War was born that day. A year later, after his most famous campaign, in the Shenandoah Valley, the name Stonewall Jackson could strike terror in the North, for no one knew what he might do next. The lush Valley served the Confederacy as a breadbasket, and militarily it suited Lee's and Jackson's plans well: the great "covered way" was shielded on the east by the Blue Ridge; and whereas a Confederate army moving down the Valley was headed toward the northern heartland, a Union force going up the Valley was going nowhere, except away from Richmond. Here, in the late spring of 1862, Jackson routed General Milroy at McDowell; crossed Massanutten Mountain to destroy the Union garrison at Front Royal; then, in the foggy dawn, crushed Banks at Winchester and chased him to the Potomac. The Federal strategy was to trap Jackson between the converging troops of Frémont and Shields (who had, between them, fifty thousand men to his seventeen thousand); but Stonewall, despite a seven-mile-long train of wagons laden with booty, slipped between them, beat Frémont at Cross Keys and Shields at Port Republic, then vanished as swiftly as he had come, turning up next on the peninsula to join Lee. In thirty-eight days, the Stonewall Brigade (men who were as often barefoot as not) had marched four hundred miles—almost all over secondary roads or mountain paths—fought three battles and a number of smaller engagements, winning them all, throwing the enemy into a state of utter confusion, and causing the bewildered Union headquarters to withhold six commands from support of McClellan on the peninsula. "We have no definite information as to the numbers or position of Jackson's force," Secretary of War Stanton admitted woefully. "God has been our shield," was Jackson's comment.

On the march, Stonewall liked to rest his "foot cavalry" for a few minutes at a time, but when he intended to surprise an enemy everything was sacrificed to speed. The men carried rations in knapsacks, and wagons were left behind. "I had rather lose one man in marching than five in fighting," Jackson liked to say, with the result that his foe was often beaten before a shot was fired. "To move swiftly, strike vigorously, and secure all the fruits of victory is the secret of successful war," he observed.

A tall, handsome man with a strong face, soft, gentle eyes, and a mild voice, Jackson never smoked or drank, and in practice of his religion, would not read a personal letter on the Sabbath. He believed absolutely in his God; to Him he gave credit for each victory, blaming himself for failure. For Jackson there were no shades of right or wrong: he did not tolerate a breach of orders. No one, including his superiors, ever knew his battle plans (letters from Richmond to Jackson in the Valley were addressed, according to his instructions, "Somewhere"). "If I can deceive my own friends," he noted dryly, "I can make certain of deceiving the enemy." His lieutenant, Dick Ewell, once remarked in exasperation: "Dammit, Jackson is driving us mad. He don't say a word . . . no order, no hint of where we're going." And on another occasion Ewell suggested the constant state of mind of Stonewall's subordinates: "I never saw one of Jackson's couriers approach without expecting an order to assault the North Pole."

The photograph of him was made two weeks before he was mortally wounded, in the moment of victory after his greatest battle, at Chancellorsville. Riding out in the dusk to inspect the front lines, Jackson and others were mistaken for enemy horsemen, and he was hit by Confederate rifle fire. Eight days later, after murmuring, "Let us cross over the river, and rest under the shade of the trees," Stonewall Jackson died. He was thirty-nine years old.

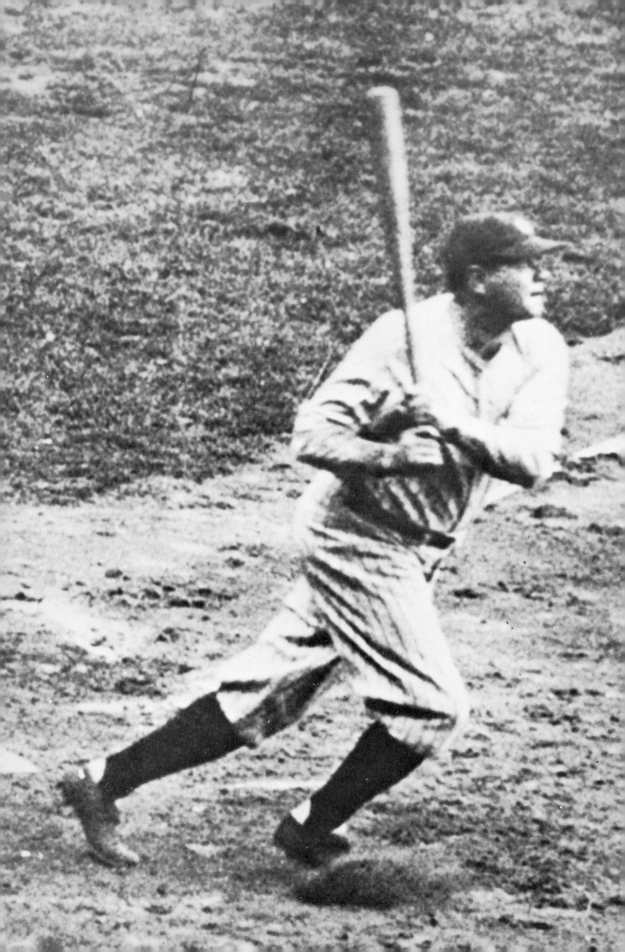

It was a picture every American boy could see, in his mind's eye: the ball park packed with people suddenly gone mad as a large man wearing the number 3 on his striped uniform selects a big, heavy bat, steps from the dugout, and makes his way to the plate. In the batter's box he stands with feet close together, his body erect, peering at the pitcher; the bat, cocked over his left shoulder, is held so far down that his little finger curls over the bottom of the knob. The pitcher goes into his windup, the ball streaks toward the plate, and at the last instant the big man takes a long stride and whips the bat around with his powerful wrists. There is a sharp crack of wood against leather and the ball rockets high into the air, up and up until it is no more than a tiny white dot, soaring from sight over the top tier of the grandstand. In the bleacher seats boys jump up and down, howling deliriously, and grown strangers embrace, thumping each other on the back, for the mighty Babe Ruth has just hit another home run.

In all of America there was no spectacle quite like it. In truth, there was no one like the Babe. Even when he missed, the crowd roared approval, for the misses were on such a Gargantuan scale, performed with such murderous intent, that failure could be as spectacular as success. The Babe swung at a pitch with everything he had, the force of the magnificent effort whirling him around until his body and legs were twisted like a wrung washcloth.

The contradiction of his name was in the American tradition—the word "Babe" to describe a big-boned man, six feet two inches tall, with a torso that looked like a barrel, awkwardly supported by spindly legs that might have belonged to a woman; the nickname "Bambino" to depict a homely man with outsize head and broad, wide-nostrilled nose. His success was in keeping with tradition, too. The son of a Baltimore saloonkeeper, he was sent at the age of seven ("I was a bad kid," he said, bluntly) to St. Mary's

Industrial School to learn shirtmaking. What he learned superbly was to play baseball, first as a left-handed catcher (playing with a right-hander's glove), then as a pitcher. When he was nineteen, the Baltimore Orioles signed him; within months he was traded to the Boston Red Sox, where, in his first full year, he won eighteen games and lost six. In each of the next two seasons he won twenty-three games, but it was becoming apparent that he was too valuable a hitter to play only every fourth game or so, and the Red Sox manager began using him as an out-fielder on days he didn't pitch. In 1919, his last year with the Sox, Babe responded by smashing twenty-nine home runs—more than any major leaguer had ever hit. By that time, also, he had compiled another remarkable record, one that stood until 1961, and one that Ruth himself seems to have been proudest of: he had pitched twenty-nine consecutive scoreless innings in World Series play.

A few years after he joined the New York Yankees, Babe's salary was the highest in baseball (by 1930 he was receiving more than the President of the United States); a cigar and a candy bar had been named for him; boys in America worshiped him; boys in Europe and Asia revered his name and exploits; Yankee Stadium was known as "The House That Ruth Built"; and wherever Ruth and the Yankees played, crowds thronged to see them, for the Babe was the greatest drawing card the world of sport had ever known. America in the Twenties took Ruth to its heart, delighting in his extracurricular antics, his feuds with manager and owner, his refusal to train, his Falstaffian appetites. It thrilled to stories about Ruth and the youngsters he never tired of seeing. A favorite was the one about the Babe visiting a boy who was dying, following an operation: the great man gave him a bat and an autographed ball and then promised to hit a homer for him that very afternoon. Of course he hit it, and of course the boy recovered; that was the stuff of heroes and legends.

The Chicago "Black Sox" scandal had broken the year Ruth became a Yankee; the previous fall, a group of Chicago players had sold out to gamblers and thrown the World Series, and the revelation of their treachery was the darkest day in the history of organized baseball. Fortunately for the future of the sport, Babe Ruth was keeping the paying customers' minds off the recent disgrace by hitting fifty-four home runs—an unheard-of total—and demonstrating, in doing so, that the character of the game had changed irrevocably. In the early days, over the fence was out; for one thing, that kind of home run might cost a team its only ball. The old game had been epitomized by Wee Willie Keeler, a scientific hitter who "hit 'em where they ain't," but the Babe put an end to all that. The only science to his hitting was in placing more balls over the outfield fence than any predecessor had done, and the fans loved it. (The picture of him was taken September 30, 1927, as he hit number sixty, a record never equalled in a 154-game season.) As it became evident that what they wanted was long hits and lots of them, baseball changed to satisfy the customers; fewer hitters choked the bat, fewer hit the "Baltimore chop." Everyone swung for the fences now. But no one ever did it in the grand manner of Ruth, and no one approached him in the crowd's affections. There was, if you thought about it, no special mystery about the Babe's success. Americans had always preferred quick, simple, clear-cut solutions to their problems. Home runs, as the Babe hit them, met all those requirements.

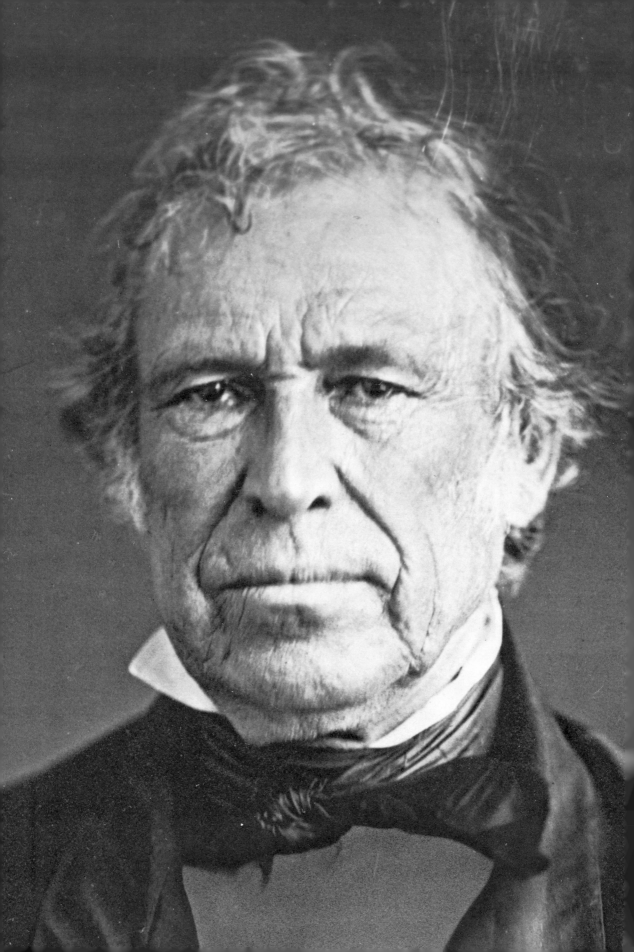

The dark troubles of disunion that beset America as mid-century approached called for a man who had slain dragons (or one who appeared to have accomplished something of the sort). So the Whigs, mindful that they had won their one and only presidential election with a military man in 1840, decided to enter the lists with another in 1848. He was an authentic hero, all right: Indian fighter and frontier soldier, victor over the Mexicans at Palo Alto, at Resaca de la Palma, and—most gloriously—at Buena Vista, where he had conquered Santa Anna and a force outnumbering him four to one. What if he *had* never voted for a President? He said he *would* have voted for Clay, the Whigs' candidate, in '44, didn't he? And if he belonged to no party, what difference did that make? He held strong prejudices, and prejudices were every bit as good as principles. What was even more important from a practical standpoint, he had no personal enemies within the Whig party, as did those veteran campaigners, Henry Clay and Daniel Webster.

The electorate—drawn more readily to personalities than to ideas—conjured up its image of a man who could settle all the important problems, and decided that Zachary Taylor fitted the image. Plain, honest, uncomplicated, "Old Rough and Ready" was just about what his nickname suggests; squat and thickset, he made a better appearance on horseback than on foot because his bowed legs were so short. His face was that of a reliable farmer, burned by the Mexican sun and deeply lined by years of exposure to the elements. In Mexico his casual dress had been a source of continuing amusement to the troops: he usually wore what was handy (at Buena Vista it had been an old brown overcoat), and often appeared in a floppy straw hat and a pair of antique gray trousers. Fellow officers once estimated the total value of Zack's "uniform" at $7.50.

His appeal for the voters, based in part on deeds,

stemmed also from the notion that he possessed the power to set the country right. When he did announce himself it was scarcely a resounding statement of principle: "I AM A WHIG," he proclaimed, "but not an ultra Whig." Yet that was enough to keep the voters happy; compromise, not extremes, was the order of the day. As James Russell Lowell's humorous *Biglow Papers* put it:

Another p'int thet influences the minds o' sober jedges
Is thet the Gin'ral hezn't gut tied hand an' foot with pledges;
He hezn't told ye wut he is, an' so there ain't no knowin'
But wut he may turn out to be the best there is agoin'.

When he gave an inaugural address that was one of the shortest in history, "negative and general," and poorly delivered, the crowd, ever optimistic, cheered him mightily.

In a peculiarly appropriate way, Old Rough and Ready suited the Washington of 1849. A "jumble of magnificence and squalor," it was then no more than a third- or fourth-rate town with little knots of settlement, dusty streets, and an ugly collection of brick government buildings. Lining its dusty streets was a mélange of boarding houses and hotels, swarming with backwoodsmen, speculators, place seekers, and planters. Gas lighting had been installed two years earlier, but as yet the town had no adequate public water supply or sewage system.

The Executive mansion was of little interest to most foreign visitors, who thought it lacked splendor and taste, but Americans considered it their own, and roamed through the large public rooms almost at will, admiring the mirrored walls and flowered carpets, not to mention the President and his family. There were unsightly sheds at either end of the building, and to the south was the President's Park, at the foot of which was a marsh that had been an outlet for sewage. George Francis Train, who called at the White House, left this picture of the man

who was then in charge of America's destiny:

"On arriving there, I was at once ushered into the presence of General Taylor, who sat at his desk. The presidential feet rested on another chair . . . He wore a shirt that was formerly white, but which then looked like the map of Mexico after the battle of Buena Vista. It was spotted and spattered with tobacco juice. Directly behind me, as I was soon made aware, was a cuspidor, toward which the President turned the flow of tobacco juice. I was in mortal terror, but I soon saw there was no danger. With as unerring an aim as the famous spitter in Dickens's American Notes, he never missed the cuspidor once, or put my person in jeopardy."

Another visitor thought Taylor singularly unfitted by training, experience, and aptitude for the Presidency; still another said he had not one spark of genius in his soul, and that, while his purposes were honest, "the mass of his knowledge is indeed small enough." Of his Cabinet appointments, Horace Greeley wrote: "Whenever any one of them shall drop out or be 'hove over,' he will sink like a stone and never be heard of again." In all truth, there was nothing wrong with the homely virtues he possessed except their hopeless inadequacy to the job and to the times. Zachary Taylor's tragedy was that his fellow Americans confused good intentions with greatness, naïvely believing that all would be well once he was in the White House. As Francis P. Blair observed of the voters' taste in Chief Executives: "They have tried Tyler and Polk, and yet the country has not been materially hurt. If two such Presidents cannot injure the nation, nothing can!"

Only sixteen months after taking office, Taylor died (ingloriously, of too much sun, ice water, and raw fruit). And the people mourned, unaware as yet that his short term had begun a decade of unparalleled failure to find a national leader. Not until 1860 did the major parties nominate men capable of greatness. By then it was too late to save the Union.

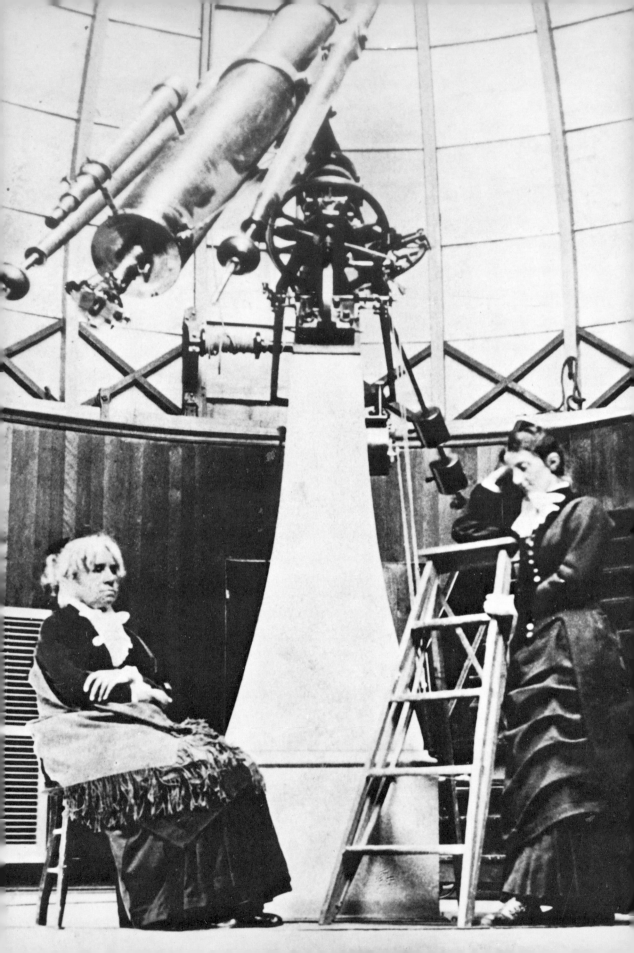

Her mien was as plain and uncompromising as her treasured brass telescope, her life a long and relentless pursuit of the truth. At the age of twelve, Maria Mitchell observed an annular eclipse of the sun with her father, helping him to make and record his calculations, and for nearly six decades thereafter she was never out of touch with a telescope, nor her mind far from the heavens. She used to say it was an interest in mathematics—that and her father's passion for astronomy—that started her sweeping the skies. But it was also the place she lived: Nantucket. On the island, people were in the habit of observing the heavens; everyone there was aware of the changes of the moon and stars, for to them the phrase "when my ship comes in" had a literal, not a figurative, meaning. The majority of Nantucket men were gone, often for years at a time, to the vast, lonely waters where the sperm whale traveled; and as a consequence, it was customary for the women of the island to run businesses as well as households, to substitute for their absent men in nearly every way.

By day Maria taught school, urging her students to observe, to open their eyes, to question. By night she and her father watched the stars from the walk on top of their Vestal Street house, faithfully recording their observations in a journal. On October 1, 1847, William Mitchell wrote in his notebook the words that were to bring his daughter worldwide fame: "This evening at half past ten Maria discovered a telescopic comet five degrees above Polaris. Persuaded that no nebula could occupy that position unnoticed, it scarcely needed the evidence of motion to give it the character of a comet." This was her initial contribution to astronomy, and her achievement brought her a gold medal—an award established by Frederic VI, King of Denmark. It was the first such prize given to an American and the first to a woman anywhere. Maria quickly became known as the "Lady

Astronomer"; she was the first woman elected to the American Academy of Arts and Sciences and to the American Association for the Advancement of Science. With all her honors she continued to do housework, to serve as librarian at the Nantucket Athenaeum, and to make her observations every night, goaded by thoughts that "the world of learning is so broad and the human soul is so limited in power." She realized that "we reach forward and strain every nerve, but we seize hold only of a bit of the curtain that hides the infinite from us."

Late in August, 1862, she learned from Rufus Babcock, a trustee of the new women's college founded by Matthew Vassar, that she was being considered for a position there. Since this was a time when women as well as men were disturbed by the idea of educating women, the new college was thought of—and not only by its Poughkeepsie neighbors—as "Vassar's folly." "Open the doors of your colleges to women," one man predicted, "and you will accomplish the ruin of the commonwealth." In going to Vassar, Maria hoped to find "students who would tax my utmost powers" and some "who shall go far beyond me." She and her father arrived at Vassar Female College in 1865 and moved into the observatory that had been built for her. In the dome was a new twelve-inch telescope (in the photograph, taken in 1888, just before her retirement, she is seated beneath it; the young woman at right, Mary Whitney, was her assistant). Maria and William Mitchell had their sitting room in the clock room, surrounded by a brass chronograph, a marble sidereal clock, and bookcases filled with their volumes on astronomy.

It was at once apparent to the Vassar students that Maria Mitchell was a superb teacher. Insisting on accuracy and demanding the utmost of them, she managed to instill in the young women a sense of the order and beauty of the universe. Hers was the method that characterizes all great teaching—stimulating her students' imaginations and allowing them freedom to question.

Realizing that few of her girls would go into astronomy, she tried to give them the habit of mind that would serve in whatever they did, by enabling them to discover and test ideas on their own. "We must have a different kind of teaching," she urged. "It must not be textbook teaching. . . . It is a feeble kind of science, which can be put on a blackboard, placed in array upon a table, or arranged upon shelves. . . . If the spirit of science can be developed at all in school rooms it must be by free debate; free thought and free inquiry are the very first steps in the path of science."

She did not believe in marks ("You cannot mark a human mind," she liked to say), nor did she require students to attend class (a "teacher of any magnetism" need not worry about students being absent). Most college rules she considered absurd—especially the ones prescribing dress, manners, and discipline—and her career at the college was a running battle against conformity. To those troubled by the implications of Darwin's *Origin of Species*, she advised that the revelations of God through the Bible and through Nature are never in conflict; "If they seem to be," she observed, "it is because you do not understand one or the other." And when her own views were questioned, she was philosophical: "The prison and the stake have passed away but the scientist who ventures to push his thoughts beyond received tradition must even yet expect to hear himself branded with the name infidel."

As time passed, she devoted more of her energies to the fight for woman's rights—in education and in other fields—and to the goal of equality in all respects with men. In her seventieth year she retired, and six months later, after noting matter-of-factly, "Well, if this is dying, there is nothing very unpleasant about it," her stay on this planet came to an end.

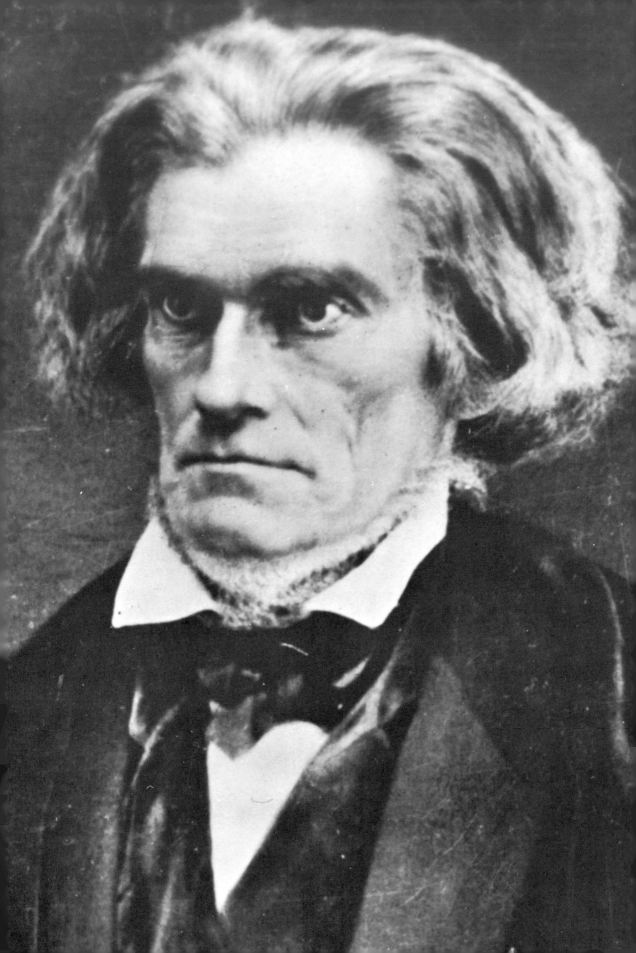

The session of Congress that opened on December 3, 1849, was regarded by men of the day as the most important ever held, for it was one that could well decide if the Union would endure. The unhappy factionalism caused by territorial expansion had come to a head over the question of California and whether it would be admitted as a free or slave state. Once again, the festering problem of slavery was out in the open, to arouse the worst passions of which the nation was capable. In this situation, the House of Representatives required three weeks and sixty-three ballots to elect a Speaker, and it was apparent that neither that body nor President Taylor was equal to the mounting crisis. The eyes of the country turned, as they had so often in recent years, to the Senate, and in particular to the great triumvirate of Daniel Webster, Henry Clay, and John C. Calhoun.

Clay, the most respected and beloved man in America, began the debate in January with an impassioned plea for moderation and compromise, and as he spoke, men watching John C. Calhoun wondered if the southerner would be able to rally his strength to reply. Wrapped in flannels, the Carolinian was "so pale and thin" that he "looked like a fugitive from the grave." Once he had been called a "cast-iron man who looks as if he had never been born and could never be extinguished," but for over a year now his health had been declining; he had fainted three times in the Senate lobby during the previous session, and these days he kept mostly to his room at Hill's boarding house, in pain, racked with coughing, trying desperately to prepare for the ordeal ahead. During the last days of February, 1850, as the breaking point between North and South loomed closer, Calhoun decided that the only way he could present his views was to write them out and have an associate deliver his speech.

On Sunday, March 3, word flew through the capital that the South's great spokesman would come to the

Senate chamber the following day for what must surely be his final appearance. Long before the session was called to order, "a brilliant and expectant audience" crowded the galleries and floor of the Senate, awaiting the grim, powerful southerner who was at the very apogee of his fame, the man one southern newspaper called "the moral and intellectual colossus of the age." Finally there was a stir at the door, and the great, gray-maned head of Calhoun was seen. A hush fell as he entered the chamber and was helped to his seat by friends. As he sank into it, his head was lowered in pain, and his bony, clawlike hands clutched the arms of the chair while he gathered his strength. Then he rose to his feet and stood erect, the wild eyes burning, the mouth a harsh slash across his jaw, and in a strong, clear voice he thanked the Senate for its courtesy, begging its indulgence while a colleague, James Mason of Virginia, read his speech. As Mason read, Calhoun sat "like a disembodied spirit," his long, black cloak pulled around him, his face drawn and white, and there were those who listened to his words who saw death written upon the South and upon the Union as it was on Calhoun's face. For it was immediately clear that he had no concessions to make, no compromise to offer. A realist, he knew that compromises are possible only between equals, and the South was no longer the equal of the North, either in economic or political strength.

Calhoun's active political life, from 1810 to 1850, had coincided with a period of immense change. He had stood against that change, trying to maintain the provisions of an eighteenth-century Constitution, striving to preserve the economic vitality of his own agrarian world against the onrushing tide of industrialism, defending a way of life that had existed in the days of the Virginia dynasty. His address traced the causes of the South's discontent, spoke of the growing concentration of power in the central government, described how the rights of the states

had been swept away and control of the central government seized by the North, and bemoaned the fact that even spiritual ties between the sections—those represented by churches and political parties—were breaking up. Unless the North would concede the South equal rights in the new territories, he said, give up the fugitive slaves it was protecting, cease the "agitation of the slave question," and restore "the original equilibrium between the two sections," the North and South should agree to part in peace.

More than most of his contemporaries, Calhoun knew that time was running against the South; he perceived the significance of the North's population growth, of its material strength, of its deep popular feeling against any extension of slavery. In urging the South to secede, he was prompted by a belief that it must do so at once, acting while it had the strength to get out of the Union and stand alone. To compromise now was only to patch up the burning issue temporarily, for the Union could not endure, Calhoun argued, when the Constitution was used to defeat the very ends it was written to maintain. He believed that the goal of democracy is equity, not equality, and that it was not democracy when "fifty-one per cent of the people have a moral right to coerce forty-nine per cent." If popular majority became the ultimate law, he argued, the Constitution would be so much scrap paper.

Even as his last words were heard in the Senate, Calhoun knew that he had failed, and four weeks later, on March 31, he was dead. Bells tolled the news that the South's champion was gone, causing one man to observe that his philosophy had summed up "a whole people and a whole civilization." A similar thought crossed the mind of a Yankee soldier, some fifteen years later. As he stood amid the ruins of Charleston, South Carolina, and looked down upon Calhoun's tomb, it occurred to him that "the whole South is the grave of Calhoun."

81

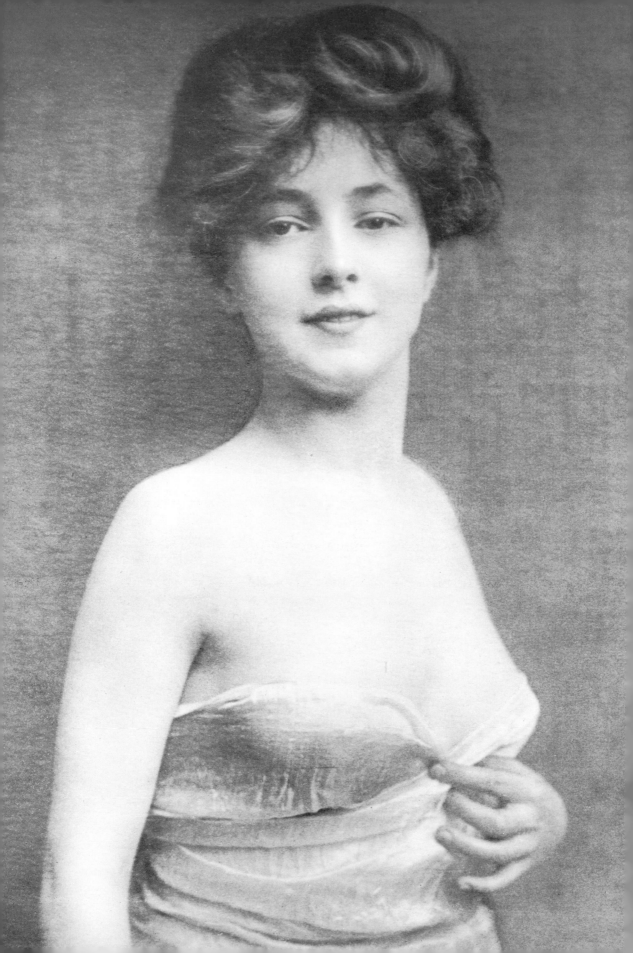

Anumber of people who attended the opening of *Mamzelle Champagne* at the roof theater of Madison Square Garden noted the arrival of Mr. and Mrs. Harry Kendall Thaw and their two male guests. Young Mrs. Thaw, the former showgirl Evelyn Nesbit, was well known as one of the beauties of New York, and her husband, the thirty-five-year-old heir to a Pittsburgh rail and coke fortune, had achieved notoriety as an irresponsible playboy who was continually in the news: he once drove an automobile through a display window; he tried to ride a horse into an exclusive club that had blackballed him from membership; he reportedly gave an elaborate dinner in Paris at which the only guests were women of questionable reputation and the favors were pieces of jewelry; at another of his parties music had been provided by John Philip Sousa's entire band.

On that opening night—June 25, 1906—*Mamzelle Champagne* dragged badly (Mrs. Thaw described it as "putrid"), but no one seems to have observed Thaw leaving his table. When a member of the cast began singing "I Could Love a Million Girls," three pistol shots suddenly cracked, and the audience whirled around to see a man slump in his chair and slide to the floor, silver and glassware crashing about him. Standing beside him, Harry Thaw held a pistol in the air as if to signal the end of the deadly business; then he walked back and joined his wife and friends.

"Good God, Harry!" she cried, "What have you done?"

"It's all right, dear," he replied, kissing her. "I have probably saved your life."

At that, a fireman on duty at the Garden disarmed Thaw and a policeman led him to the elevator. Behind them the panicky crowd and the girls from the chorus clustered around the fallen man. Lying dead in a pool of blood, his face blackened beyond recognition by powder burns, was Stanford White, fifty-two-year-old

man about town (a "voluptuary," some called him) and America's most famous architect, whose proudest achievement was Madison Square Garden.

Six months later the most sensational trial in the country's history began, a trial that revealed to plain people everywhere the hypocrisy of Victorian morality. Although Thaw was on trial for his life, the high moment of drama came when Evelyn Nesbit Thaw was called to testify. Ten thousand jammed the streets to see her—a twenty-two-year-old girl who looked sixteen, dressed in a simple navy-blue suit with Buster Brown collar and a black bow ("the most exquisitely lovely human being I ever looked at," wrote Irvin S. Cobb)—and a shocked nation began to witness what one commentator called "the vivisection of a woman's soul." Some years later Evelyn wrote grandiloquently, "I was sacrificed on the altar of a strait-laced morality born out of mid-Victorian prudery."

Evelyn, it was clear, had come a long way from Tarentum, Pennsylvania, where she was born. Detail by lurid detail, the prosecution took her through the story of how she had become an artist's model at fourteen, then a showgirl with the hit musical *Florodora*. Along with other prominent New York men, Stanford White had arranged to meet her, and in his apartment one night, she said, he gave her drugged champagne and ravished her. After she became his mistress, White delighted in setting her naked on a red velvet swing and pushing her so high her feet touched a Japanese parasol that hung from the ceiling. In 1903 she left White for Thaw and went on the first of two premarital trips to Europe with him. She returned home alone, took up with White again, and revealed to him the sadistic brutality she had suffered at Thaw's hands after he learned of her relationship with White. Then—despite all she had discovered about the unbalanced Thaw—she left for Europe with him again. As most reporters perceived, it was Evelyn, not her husband, who was on trial: the prosecutor

stated in his summation that she was a "tigress between two men, egging them on. To Thaw she said White had wronged her. To White she said Thaw had beaten her with a whip." Since White was married and could not give her respectability, she had decided in 1905 to marry Thaw. A year later her husband, who went into paroxysms of rage at the mention of White's name, could stand his jealous doubts no longer and killed the architect.

Three and a half months after the trial began it ended with a hung jury; so nine months later the whole sordid tale was recited before another jury, which concluded that the defendant was not guilty, on grounds of insanity. But the judge, declaring Thaw a manic-depressive and dangerous to the public safety, committed him to the Matteawan State Hospital for the Criminal Insane. Much of the next fifteen years he spent in asylums; in 1924 he was released and lived in semiseclusion, except for occasional colorful encounters with police and press, until his death in 1947.

For Evelyn, the years that followed the trial were all downhill: squabbles with Thaw and his family over money, affairs with other men, divorce, suicide attempts, nightclub acts that took her into ever tawdrier cabarets, run-ins with the curious and the police. Through it all she made a living recalling her vicissitudes and the sensational trial in different versions of her "own true story." In 1934 she told it again in a book, *Prodigal Days*, and in 1955 she was hired as "technical consultant" for a motion picture, *The Girl in the Red Velvet Swing*, which purported to be her life story. Finally, at eighty-two, she died in a convalescent home, all too aware that for the lovely young girl life had ended that night sixty years ago at the roof garden. "Stanny White was killed," she said, "but my fate was worse. I lived."

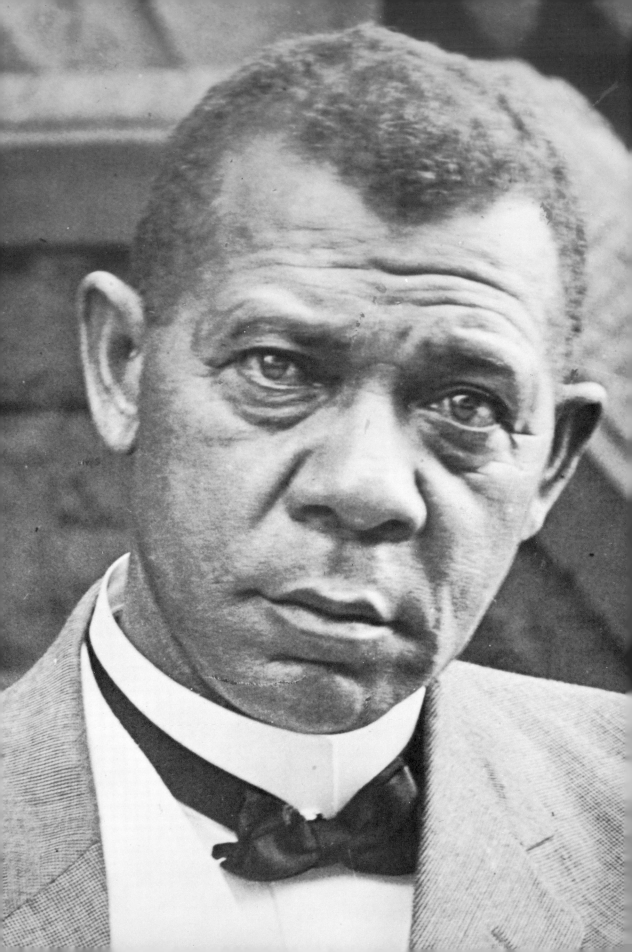

The most damnable outrage ever!" the Memphis *Scimitar* called it. President Theodore Roosevelt, it was learned, had entertained a black man at dinner at the White House, and the reaction was about what might have been expected in America in 1901. One southern newspaper described the affair as "a crime equal to treason"; an editor warned that "no Southern woman with proper respect would now accept an invitation to the White House." And "Pitchfork Ben" Tillman, the irascible, one-eyed, unsuccessful farmer who was now a senator from South Carolina, spoke for the militant racists: "Entertaining that nigger," he said, would "necessitate our killing a thousand niggers in the South before they will learn their place again."

The object of this furor was a forty five-year-old, mild-mannered gentleman who had been a slave until about the age of nine. The son of a Negro cook and an unknown father—possibly a white man from a neighboring plantation—he was born in "the most miserable, desolate, and discouraging surroundings" on James Burroughs' plantation in Franklin County, Virginia. With his mother and two other children he lived in a fourteen-by-sixteen cabin which had an open fireplace, a door, several uncovered openings in the walls, and a potato-hole in the middle of the dirt floor, where vegetables were stored. He couldn't recall ever sitting down to a meal with his family; slave children simply picked up scraps of bread or meat whenever they could, and often he breakfasted on boiled corn that the pigs had left on the ground around the trough. His first shoes were made of wood, and he remembered with horror the flax shirts he had to wear—before you broke them in, it was like having "a dozen or more chestnut burrs, or a hundred small pin-points" next to your skin. Equally memorable was his first glimpse of a school; he had walked as far as the schoolhouse door, carrying books for one of his

young mistresses, and, looking inside and seeing several dozen boys and girls studying, imagined it to be "about the same as getting into paradise."

His first realization that he was a slave came early one morning when he awoke to find his mother kneeling over her children, praying that Mr. Lincoln and his armies would be successful so that she and the little ones might be free. For years the Negro grapevine had passed along the presentiments of freedom—the words of Garrison and Lovejoy, Brown and Lincoln—and late at night in the slave quarters there would be whispered discussions about events far to the northward. Slavery was what the war was about, they knew, and Union victory would mean the end of slavery. During the spring of 1865 freedom was in the air, and as the great day drew closer there was more singing in the slave huts than ever—bolder songs, with more of a ring to them. One momentous morning all the slaves gathered around the veranda of the big house while a stranger—a U.S. Army officer— made a little speech and read the Emancipation Proclamation. When the boy turned to his mother he saw tears of joy streaming down her cheeks.

For a time there was rejoicing, but when they returned to the cabins the boy saw a change come over the Negroes: "The great responsibility of being free, of having charge of themselves, of having to think and plan for themselves and their children, seemed to take possession of them." And in the months to come he learned more about the demands liberty makes upon people. He saw, among other things, a whole race beginning to go to school for the first time (many of the older folk so they might learn to read the Bible before they died). He went to work in a salt furnace, starting at 4 A.M. so that he might get to school by nine. And here for the first time the boy acquired a name—always he had been called Booker, but when the teacher asked for a surname he had to make one up: "Washington," he announced

proudly. Not until later did he discover that his mother had named him Taliaferro, but Washington was his choice, and as Booker Taliaferro Washington he worked his way through Hampton Institute, taught school (children by day and adults at night), and in 1881 was asked to take charge of what was to be a normal school for Negroes in Tuskegee, Alabama. There was not much there to begin with—"a broken-down shanty and an old hen-house" in such bad repair that one of the students had to hold an umbrella over their teacher when it rained—but by the time he died in 1915 the institution owned nearly thirty thousand acres of land, one hundred buildings (many built by the students), had an endowment of two million dollars, and was teaching thirty-eight trades and professions. "I want to see education as common as grass, and as free for all as sunshine and rain," Washington once said, and in this belief he plunged ahead, making Tuskegee an institution that commanded the respect and support of an entire community—and eventually of the nation—by providing what the community needed.

To some Negroes of his own day—and to many a half-century later—"Booker T." seemed as out-of-date as his collar, a subservient "Uncle Tom," willing to bow before the Jim Crow laws which came in during the latter part of his life. The young N.A.A.C.P. criticized his failure to push for political rights and his emphasis on industrial education; might that not keep the race in a new bondage? But Washington left no doubts about his philosophy: he was more interested in making his race worthy of the vote than in agitating for it. He believed they would be granted it some day, and he wanted them to be ready when the great day came. He could be patient with both races—as he demonstrated after the storm broke over his visit to the White House. "It is the smaller, the petty things in life that divide people," he observed. "It is the great tasks that bring men together."

The image is all but gone from the glass plate; what remains is a faded shadow of the man and his daughter, frozen forever in the interrupted moment of their chess game. When this picture was taken, Clement Clarke Moore was past middle age, with most of his achievements behind him, with the way of life he had known in rural Manhattan disappearing. Born midway through the Revolution, he would die seven days after the Battle of Gettysburg, his eighty-four years spanning the birth and breakup of the Union.

The society in which he grew up was that of a landed aristocracy virtually unchanged from pre-Revolutionary days—a gentle, courtly, leisurely world. His maternal grandmother, an unreconstructed Tory, left his parents her handsome three-story house, called Chelsea, on a wooded hill overlooking the Hudson River at what is now Twenty-third Street between Eighth and Ninth avenues. She also bequeathed them a Jersey salt meadow, four slaves, and lands upstate which had been part of a 400,000-acre patent from the Crown. Clement Moore would have no real financial burdens thrust upon him. Nor would his grandmother's politics prove a great drawback: his father, an Episcopal minister (later Bishop of New York) who had taken no sides in the Revolution, was asked to participate in George Washington's inaugural and was called to the side of the dying Alexander Hamilton after the duel with Aaron Burr.

Although he published works on several other subjects, Moore's abiding interests were language and religion. After graduating from Columbia College at the head of his class, he began work on *A Compendious Lexicon of the Hebrew Language,* which he brought out in 1809, hoping it might break down his countrymen's resistance to the study of Hebrew. (Apparently he did not feel the need to defend the other languages in which he was fluent— Latin, Greek, French, German, and Italian.) In 1819 he

offered a part of his estate to the Protestant Episcopal Church, making possible the building of its General Theological Seminary, where he became professor of Biblical learning and for twenty-five years taught Oriental and Greek literature. He was also a benefactor of St. Peter's Church, where he served faithfully as organist (given his interests, it may have been no accident that the church pews were marked with Roman numerals).

As the years passed, the burgeoning city began to crowd in on Chelsea. Twenty-third Street became a busy thoroughfare; rows of small brick houses began to go up where there had been fields; woodland and marshes disappeared. Eventually nothing but the memory of the Moore house survived, in the name Chelsea Square. And if Moore himself is remembered at all today, it is usually for a poem he wrote with no thought of publication, but as a Christmas gift for his family.

Sometime in December of 1822, he composed twenty-eight couplets of a ballad, and on Christmas Eve read them to his five children. The tale he told was not unfamiliar, for Washington Irving had written of the legend in Diedrich Knickerbocker's *History of New York*; neither were the characters—members of the family at once recognized themselves as well as the chief protagonist, whom Moore had modelled on "a portly, rubicund Dutchman living in the neighborhood." But just possibly they perceived that the verses captured more than the familiar, more than the love and warmth of that household at Chelsea; that they told of innocence and wonder and simple belief, of the breathless anticipation of childhood; and that they were for every family that cared enough to listen.

A relative who was there on Christmas Eve copied the poem into an album; a friend of hers from Troy, New York, read it, recorded it again, and gave it to the editor of the Troy *Sentinel*. A year later, in the issue of December 23, 1823, he wrote: "We do not know to whom we are in-

debted for the following description of . . . Santa Claus, his costume, and his equipage, as he goes about visiting the firesides of this happy land, laden with Christmas bounties." Not only was the poem anonymous, as far as the editor knew, but it had no title. So he set a line of type over it reading: "An Account of a Visit from St. Nicholas," and then printed the words Clement Moore had written:

'Twas the night before Christmas, when all through the house
Not a creature was stirring, not even a mouse;
The stockings were hung by the chimney with care,
In hopes that St. Nicholas soon would be there. . . .

Each year a few more newspapers picked up the poem around Christmastime, and although the author never thought it worth publishing, in the early 1830's it was printed as a little book with illustrations by Myron King, an obscure Troy engraver who brought Moore's old elf to life. In 1844, when it appeared in a collection of his poems, Moore remarked in the preface that it was only one of many "mere trifles . . . [that] have been often found to afford greater pleasure than what was by myself esteemed of more worth."

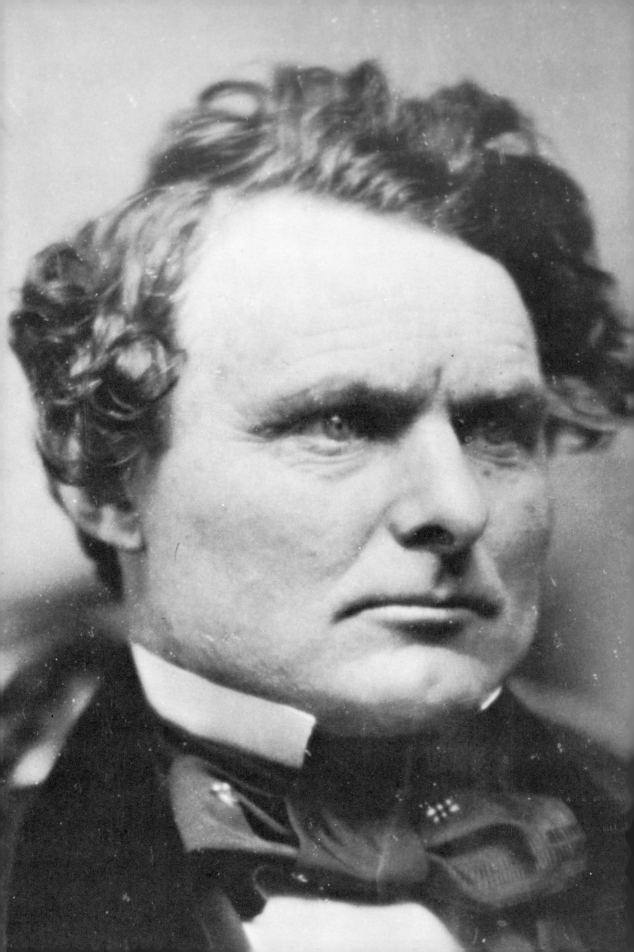

Three decades of his life had been devoted to a single passion—a passion that took him to the very pinnacle of success. Then the era he had helped to create began to fade, and one could see in his face an awareness of the onrushing winds of change. The year was 1855, and the burst of genius and energy which had made America, for a time, the greatest maritime power in the world was being drowned by forces beyond anyone's ability to control.

From Nova Scotia, in 1826, Donald McKay had come to New York—his passage on a coaster paid with the savings of his mother and father and brothers—and at the age of sixteen he signed an indenture to Isaac Webb, the shipbuilder. The terms were harsh: he was to work from sunrise to sunset, six days a week, for $1.25 a day. As soon as he was released from the agreement, McKay took a job in another shipyard, and by night drew plans, studied mathematics, modeled hulls, and talked to the men who sailed the oceans of the world. By the time he was thirty-four he had his own shipyard in East Boston and was beginning to make a name for himself constructing packets; five years later, in 1850, he launched his first clipper ship, the *Stag Hound*; the next year the *Flying Cloud* came down the ways.

The clippers which Donald McKay and his fellow builders produced were not only the fastest ships afloat; they were incomparably beautiful—a reflection of the American's love of speed and grace, of his preference for the new and daring over the old and established. Long, thin-waisted craft, towering above everything else in port, their bowsprits forming great arches along the bustling waterfronts, they could be spotted even by the greenest landsman. Once at sea, they were driven by as tough and skillful a lot of skippers as ever lived; until they reached Cape Horn and the savage battle that might last for weeks against the shrieking westerly gales, they carried every

yard of canvas that could be spread—including, sailors said, the captain's long drawers.

Donald McKay's *Flying Cloud*, 1,783 tons, set sail on her maiden voyage from New York on June 3, 1851, with Josiah Cressy in command and his wife as navigator. In the Atlantic squalls the ship lost most of her top hamper and sprung the mainmast; a mutiny nearly broke out; then she ran head-on into screaming southwest winds and thick snow while rounding the Horn, and the men were sent aloft—up and up, one hundred feet above the dark, surging water—to make repairs while the ship rolled and tossed in the wild storm. But eighty-nine days and twenty-one hours later the ship came flying through the Golden Gate—a record east-west passage that would be equaled only twice by sailing vessels (once by the *Flying Cloud* herself). After unloading, she headed west again—this time to China for a cargo of tea—and when she returned to New York, only ninety-four days out of Canton, the city went wild, Captain Cressy was given a hero's welcome, and Donald McKay's name was on every merchant's lips. But McKay was not satisfied.

In 1852 he built the 2,400-ton *Sovereign of the Seas* on his own account, since no one was willing to order so large a ship, and he gave her command to his brother Lauchlan. There was a public holiday in Boston when she was launched, another celebration in New York while she was being loaded for California, and when she arrived in San Francisco after a harrowing voyage, she showed a clear profit of nearly $100,000. The next year the *Sovereign* sailed from the Sandwich Islands to New York in eighty-two days, her log showing a run of 421 miles during one twenty-four-hour period—and this voyage was accomplished with a green, shorthanded crew and a sprung fore-topmast which prevented Lauchlan McKay from carrying all the sail he wanted. From that moment, world attention centered on Donald McKay and his ships. No other builder produced such a tonnage of clippers; no

vessels were more successful than his. Instinctively, he gave them beauty along with strength and speed—even their names had music to them. In 1852, in addition to the *Sovereign of the Seas*, he launched the *Bald Eagle* and *Westward Ho*. In 1853 came the huge *Great Republic*, the *Empress of the Seas, Star of Empire, Chariot of Fame*, and *Romance of the Seas*. Yet none quite satisfied him: "I never yet built a vessel that came up to my own ideal," McKay said; "I saw something in each ship which I desired to improve."

But by 1855 there was neither time nor opportunity to improve the clipper ships. Six extreme clippers had been launched in 1854—three at McKay's shipyard—but none was ever laid down again in the United States. For too long America's attention had been focused on the West. Young men whose minds and energies would have turned naturally to the sea a century earlier were engaged now in staking out claims and building towns. Steam was replacing sail; even in their heyday the clippers met more and more steam-powered craft, and were escorted in and out of port by stubby, snorting tugs. Man was beginning to achieve a mastery of sorts over the elements. The clipper had been his supreme, barehanded challenge to nature—a dare to come and do her worst.

For a few years the great ships held on. They were put to work hauling coal and coolies, guano and lumber; but before long they were rotting at dockside or in some lonely backwater anchorage. Donald McKay had seen this coming, and he turned his talents to steam and to building ironclads; but things were never the same with him again, and in 1869 he sold the famous shipyard. For a while he lived on a farm, and when he died in 1880 he was buried in Newburyport, just in sight of the ocean which his beautiful ships had ridden for those few glorious, exhilarating years.

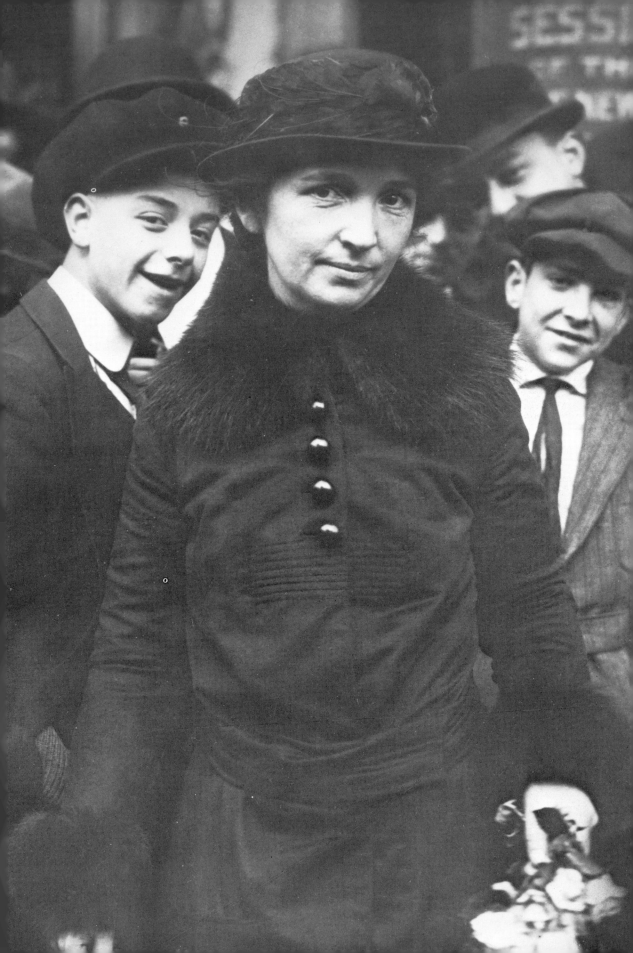

In January, 1917, outside a New York courtroom, the crowd behaved predictably: the same whispers and sly grins, the same ugly innuendoes and unreasoning anger, greeted her whenever she appeared in public; alone, facing them down, was the little woman with the shy smile and dark, penetrating eyes, determined to speak her mind and persuade those who opposed her of the sanity of her cause. A few months earlier Margaret Sanger had opened the first American birth-control clinic; as a result she had been arrested several times, and now she was charged with violating a state law that prohibited distribution of literature on contraception. The judge promised leniency if she would agree to abide by the law in the future, but Margaret Sanger was determined to test the statute. "I cannot promise to obey a law I do not respect," she said, and was sentenced to thirty days in the workhouse, where she occupied her time by giving her fellow prisoners lectures on birth control.

The sixth of eleven children born to an Irish sculptor of tombstone angels in Corning, New York, Margaret had seen her mother go to an early grave as a result of childbearing; as a nurse she had come across babies "wrapped in newspapers to keep them from the cold; six-year-old children . . . pushed into gray and fetid cellars, crouching on stone floors, their small scrawny hands scuttling through rags, making lamp shades, artificial flowers." From the day in 1912 when Margaret Sanger decided to champion birth control, the enemy was never very far away. Arrayed against her were federal and state governments, churches, the medical profession, the press, and many of her friends, but if anyone personified the opposition, it was Anthony Comstock, a self-appointed "Guardian of Purity" who was incapable of distinguishing between information and obscenity. He had been largely responsible for persuading Congress to enact legislation in 1873 that barred "obscene, lewd, lascivious, filthy and

indecent" materials from the U.S. mails. He had also succeeded in including contraceptive devices and literature about them under those headings, thus equating birth control with smut and pornography.

When in 1914 Margaret Sanger began publishing a paper, *The Woman Rebel,* that dealt with health, social hygiene, child labor, and the damaging effects of large families, the New York postmaster advised her that it could not be mailed. Not long afterward she was indicted by a grand jury on nine counts for alleged violations of federal statutes; if convicted, she could receive up to forty-five years in prison. When her case came up she asked for a stay, but the judge gave her only until the following morning. Even though it was wartime, she decided to flee to London, buying time to prepare her defense and publish a pamphlet she had just completed called "Family Limitation," in which she presented the forbidden information about birth control. In 1916 she was back in the United States, brimming with practical information concerning new methods of contraception and with renewed determination to test America's antediluvian laws. When her trial began, early in 1916, the government disappointed her by declining to prosecute (no test case meant that it was still against the law to advocate birth control).

The public, which heard so much about her views, knew very little of Margaret Sanger's private life. Her divorce from William Sanger, the father of her three children; her love affairs (including one with Havelock Ellis, the English authority on sex); her marriage in 1922 to J. Noah Slee, founder of the Three-in-One Oil Company, which brought her happiness and freedom from financial worry—none of these events overshadowed her determination to inform the public about birth control and to change the laws that prevented it. She hated speaking to large audiences, but she memorized a set talk that she delivered again and again. Her correspondence reached

enormous proportions; she wrote constantly—books, tracts, articles; she founded clinics; she launched the American Birth Control League; she journeyed abroad to spread the word. And every step was dogged by controversy. By the time opposition from Protestant churches began to wane, the Catholic Church took up the fight with a vengeance. In 1921 an overflow crowd waiting outside New York's Town Hall for a birth-control rally was locked out on Archbishop Patrick Hayes's orders, and Margaret Sanger was arrested when she tried to speak. "Children troop down from Heaven because God wills it," the archbishop announced, and any attempt to prevent the increasing tide of humanity was "satanic." As late as 1929 her birth-control clinics in America were still being raided by police, prodded by the Catholic clergy.

Each flare-up of bigotry benefited her cause, bringing discussion of birth control out in the open, providing her with an opportunity to broadcast her views. Woman's fertility, she believed, was the chief cause of human misery and resulted in poverty, famine, and war. Fewer births would mean better and healthier children, more money for each member of a poor family, better-cared-for and better-educated young people. Until her eighty-sixth year Margaret Sanger persisted. She lived to see birth control acclaimed by most Protestant churches and by the American Medical Association; the courts liberalized the interpretation of existing laws. Birth-control instruction, which she had introduced, was available in hospitals and clinics; there was increased awareness of the tragedy implicit in unchecked population growth; birth control was saving the lives of many mothers, ending their ancient fear of constant pregnancy; and, partially through her efforts, people had begun to accept sex as a normal part of life. But after her death in 1966 the urgency remained: of all births that occurred in the United States from 1960 to 1968, between 35 and 45 per cent were still unwanted.

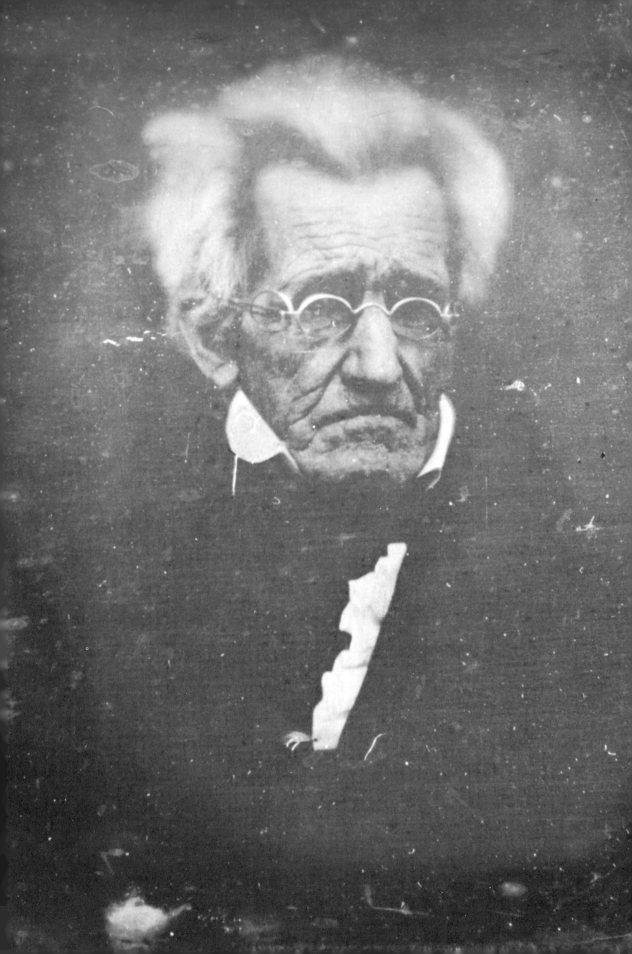

"y lamp is nearly burned out," he admitted, "and the last glimmer has come." For the past two years not a day had passed when he was free of pain; one lung was gone, the other diseased; he was tormented alternately by dropsy and diarrhea, racked by chills and fever. He sat quietly in the armchair, saving himself, a wasted figure in an old-fashioned, snuff-colored coat with high stiff collar. Beside him were his Bible, a hymnal, and writing materials; too poor to hire a secretary, and almost blind, he nevertheless did what he could to answer the flood of correspondence he received. The hand of death was on him, and each day the procession of visitors increased—people who came to say farewell and to look into the old warrior's face for the last time. The king of France sent the popular artist Healy to paint his portrait before it was too late; photographers came to take daguerreotypes.

Little remained now but the iron will—that and the memories. Occasionally a remark by an old friend would set his mind to roaming back and forth across the years, and once again he would be Andy Jackson, nine years old and "public reader" in the Waxhaws of South Carolina. Clustered about him were thirty or more neighbors, listening gravely while the shrill voice proclaimed the news from Philadelphia: "In Congress, July 4, 1776. The Unanimous Declaration of the Thirteen United States of America. When, in the course of human events. . . ."

Always there had been people around him. On the day that ended the "reign" of "King Andrew," after Mr. Van Buren had delivered his inaugural address, the ex-President descended the steps of the Capitol. And as he did a roar burst from the huge crowd, a roar of affection and gratitude and admiration such as few men have been privileged to hear. Halfway down the great steps General Jackson uncovered and bowed, and the cheers died away. Two days later the people of Washington

turned out again, this time to bid him good-by. They lined the streets, overflowed the railroad depot, and spread out across the tracks, waiting silently at every vantage point that offered a glimpse of him. Andrew Jackson stood on the rear platform, his white mane blowing in the breeze, and the hushed crowd that watched the train chuffing out of sight felt, one man said, "as if a bright star had gone out of the sky."

Sometimes now, sitting alone in his bedroom, watching the dawn come, the dying man remembered how the fog had lifted from a field of cane stubble below New Orleans and how, through the patches, he had seen the scarlet-coated regulars heading across the frosty ground, cross-belts ghostly white in the morning light, thousands of bayonets weaving and bobbing as they moved relentlessly and unwittingly toward the point where he had massed his reserve. They were only five hundred yards distant when his cannon opened on them, three hundred yards away and running forward when his riflemen fired, and of five thousand men, just twenty reached his lines. When the American guns were silent, the General looked out across the cane field again and saw five hundred British getting to their feet from the heaps of dead comrades, the quick rising up all over the plain to come forward as prisoners. It looked, he recalled, like the day of resurrection, and it was his proudest hour. Forty years earlier he had learned to hate the British; before he was fourteen the War for Independence cost him his mother and two brothers, and an English officer's sword scarred him for life. Alone in the world, he made up his mind that everyone who was not for him was against him.

Daniel Webster once said, "He does what he thinks is right, and does it with all his might," and the old man would not argue with that. There had been some good men up against him—Clay, Calhoun, Nicholas Biddle, Webster himself—and he had beaten them all. When he left the White House he had but two regrets, he told a

friend: He had not been able to shoot Henry Clay or hang John C. Calhoun. It was not enough for a man to be right; he had to be tough—you learned that fighting Indians and Englishmen. He remembered how he got the nickname: he and his Tennesseeans were on the march, hacking a road through swamps, building bridges as they went, and a lot of his boys were sick and hungry. While he walked up and down the length of the long column, encouraging them, seeing that they had rations, looking after them, one soldier had stared after him and said admiringly, "He's tough." "Tough as hickory," added another, and the name had stuck.

And Old Hickory became the spokesman for the frontier—partly because the frontier badly needed one just then, but also because the frontier wanted toughness and honesty and directness in its leaders and because Andrew Jackson feared no man. Once when he and the Bentons were feuding, Tom and Jesse Benton arrived in Nashville wearing pistols; Jackson walked into town with a riding whip and went looking for them. Once again he challenged Charles Dickinson, one of the best shots in Tennessee, to a duel, and even after Dickinson put a bullet next to his heart he stood there, slowly took aim, and shot his opponent down. "I should have hit him," he said, "if he had shot me through the brain." Thirty-nine years later Dickinson's bullet was still in his chest; the pistol that killed Dickinson still lay on the mantel of Jackson's bedroom. In his will he left a sword to his nephew, asking, characteristically, "that he fail not to use it when necessary in support and protection of our glorious Union."

Long after he died, someone asked Alfred, one of his slaves, if he thought his master would get into Heaven on Judgment Day. Alfred knew his man. "If Gen'l Jackson takes it into his head to git to Heaven," he said, "who's gwine to keep him out?"

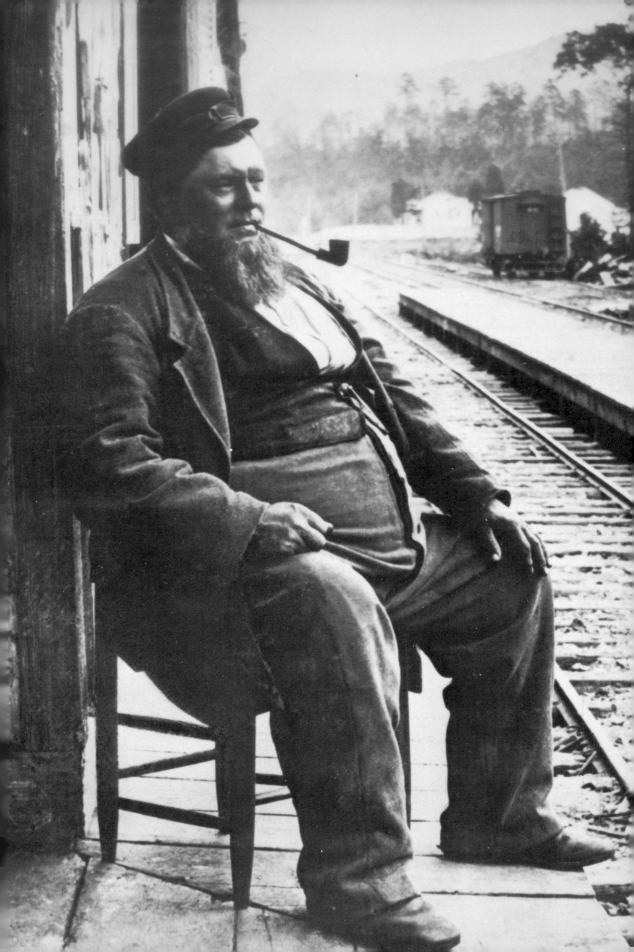

In a thousand tank towns and junctions across the land, he was a man boys wanted to be when they grew up. Wherever the railroad had come, depositing a lonely depot in its wake, he was a fixture — and a most important one: stationmaster, telegrapher, flagman, ticket salesman, and express agent rolled into one — a man who spent, it often seemed, an unconscionable amount of time just sitting peacefully in the sun or jawing with anyone who happened by to pass the time of day, but who carried out his assorted tasks as efficiently as any responsible executive would. His hours, when he was working, were busy ones; when he was not — well, time was what people had most of in 1876 in the town where he lived.

The railroad and everything associated with it fascinated boys endlessly. At the very apex of their dream of glory and ambition was the engineer — that intrepid, keen-eyed man in overalls who leaned out of his cab to wave as the monstrous black engine thundered past in a violent swirl of hissing steam and clanging metal. Keeping one hand on the throttle (there was no problem of steering, of course, so a man could take in the sights that lay along his route), he raised the other in salute, his goggled, sooty face breaking into a grin at the moment he flashed by; then, focusing his eyes on the tracks ahead, he would release a stream of tobacco juice expertly to leeward and roll on toward the horizon, an imperial figure of never-to-be-forgotten splendor. Certainly, he was a man who had everything the world could offer.

Then there was the stationmaster — somewhat lacking in the heroic qualities, to be sure, but then not everyone could get to be an engineer. And the next best thing was to be in charge of a station; to know, before anybody else in town did, when the 9:44 would actually arrive, or what the news was down the line, just by listening to the click of the telegraph key. A boy could put his ear to the rail and wait for the faint, thin hum, gradually growing stronger, that

meant a train was coming; but the stationmaster *knew*. And as custodian of all the engines and the freight and passenger cars that stopped off at his depot, he possessed all *other* kinds of important knowledge, too.

What this paragon had to be, whether or not small boys realized it, was a Jack of all the many trades related to his job. Ticket-selling does not seem an unduly onerous task, but few practitioners before or since performed the job more deliberately or with a keener eye for the bunco man passing a phony five-dollar bill than the small-town stationmaster who had to account for every penny received. It was his studied conclusion that no one ever arrived at the station to buy a ticket until the long wail of the train whistle could be heard down the tracks; and this, of course, was the very time he had to move around like a one-armed paperhanger in a swinging door. Usually someone wanted baggage checked through; as like as not he would have to see to a widow woman's household effects—all of which had to be checked, weighed, tagged, and tied up. At least once a week a 200-pound trunk would appear on the platform, waiting to be moved; there would be a sewing machine that was certain to come loose from its stand unless he found a way of securing it before it was shipped; frequently he had to locate a freight car for a lot of pigs or cattle on the way to market and then help the farmer get them aboard. As agent for the express company, he must manhandle oyster kegs and chicken crates and barrels of beer between trains, and he had to keep all the records on these and other shipments. In some depots, he served also as switch tender and crossing flagman.

Inevitably, as a train chuffed into the station, the dispatcher's click would come over the wires with a telegram for the conductor. The stationmaster would write down the message with an almost invisible pencil stub and then, inclining his pear-shaped figure forward, extend an arm across the cluttered table on which the copper and brass

telegraph key sat, shift his pipe in his mouth, and deftly and effortlessly — moving nothing but the first two fingers on his right hand — tap out a terse acknowledgment. After making out a ticket for the last anxious passenger he would jam a cap onto his head and hustle out to the platform to get his baggage and freight aboard. There he greeted the conductor with the telegram and a few wry words, waved to the engineer, and watched as the driving wheels started to spin. The engine would give off several long sighs, whoosh once or twice, then start to move, disappearing before long around a bend in the tracks and settling into a steady *puff*-puff puff-puff that slowly receded out of earshot

It was of such humdrum moments that the station-master's life was comprised, but as Henry David Thoreau observed, these events had a broader meaning for the whole community. "The startings and arrivals of the cars," he wrote, "are now the epochs of the village day. They go and come with such regularity and precision, and their whistle can be heard so far, that the farmers set their clocks by them, and thus one well-conducted institution regulates a whole country."

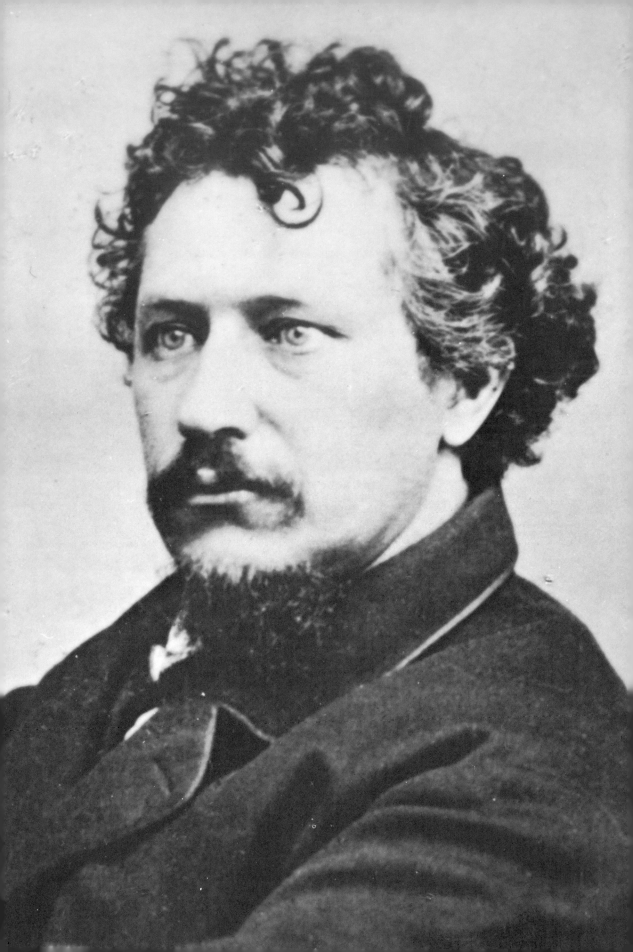

The idea of becoming a candidate for President of the United States first came to him in a Dublin jail. ("A jail," he observed philosophically, "is a good place to meditate and to plan in." And he should have known: he was incarcerated fifteen times during his life—always in behalf of some cause, for, in his own words, he "never committed a crime, cheated a human being, or told a lie.") As the election of 1872 approached, the man's confidence in himself was sublime; the record he offered American voters, unique. Describing his qualifications, he said, "I am that wonderful, eccentric, independent, extraordinary genius and political reformer of America, who is sweeping off all the politicians before him like a hurricane, your modest, diffident, unassuming friend, the future President of America—George Francis Train!"

Orphaned at the age of four, he had become a shipping magnate in Boston while still in his teens, and when he was twenty-four sailed for Australia, where gold had been discovered. To that raw, backward land he brought feverish energy and ideas by the score, introducing prefabricated buildings, Concord coaches, canned goods, bowling, Fourth of July celebrations, and free champagne lunches. When his wife became pregnant, he sent her home to give birth in the States; if the child was a boy, he explained, he wanted no technicality to stand in the way of his becoming President of his country. Soon afterward, miners in the gold fields revolted against the Australian government, tried to set up a republic, and offered Train the presidency. But he had decided to move on.

In America he promoted a railroad on behalf of María Cristina, Queen of Spain. In England he introduced cheap public transportation in the form of horse-drawn streetcars; while laboring to sell street railway systems, Train also served his country as an unofficial ambassador. He made speeches, he wrote pamphlets, he published a newspaper—all to keep Great Britain from entering the

Civil War on the side of the South. And while not otherwise engaged, this human dynamo found time to make a few practical suggestions to the backward British: unloading coal wagons by means of a chute; putting rubber erasers on the ends of pencils; perforating sheets of postage stamps to make tearing easy; and adding pouring spouts to the mouths of ink bottles. Back in America, he secured a charter from the U.S. Congress to build what became the Union Pacific Railroad. Commodore Vanderbilt, to whom he broached the idea, told Train: "If you attempt to build a railway across the desert and over the Rocky Mountains, the world will call you a lunatic." Undaunted, Train organized financing for the line by means of an ingenious scheme he had heard about in France—the Crédit Mobilier. Fortunately, he was out of Crédit Mobilier before it collapsed in scandal—he had gone on to bigger and better things.

His campaign for the Presidency began in earnest in 1869, when he had just turned forty. He planned to make 1,000 speeches, and he not only made them but successfully charged admission—collecting a total of $90,000 during three years of barnstorming. By the end of 1871 Train calculated that he had spoken directly to two million people. So long as he could reach them by voice or by shaking hands he could hold them, he thought; "but the moment they got out of my reach they got away from me, and slipped back again to the sway of the political bosses." Something of the sort must have happened, for when the final returns were in, U. S. Grant had 3,597,132; Horace Greeley, 2,834,125; Charles O'Connor—the first Catholic to run—29,489; prohibitionist James Black had 5,608; Victoria Claflin Woodhull, the free-loving Equal Rights party candidate, received a few popular votes; George Francis Train got none.

One of the more colorful episodes in a kaleidoscopic career occurred toward the end of the campaign. Learning that Victoria Woodhull and her sister Tennessee

Claflin had been jailed on an obscenity charge for publicizing the Reverend Henry Ward Beecher's love life, Train printed three columns of verses from the Bible in his own newspaper, insisting that "every verse I used was worse than anything published by these women." He was promptly jugged. When the judge refused to hear the obscenity charges and decreed him a lunatic, Train moved the magistrate's impeachment and made his departure from jail wearing nothing, it was said, but an umbrella.

Earlier, he had interrupted his campaign to make a dramatic—indeed, spectacular—trip around the world. Setting sail from San Francisco in August, 1870, he made Yokohama "in very good time," went to Tokyo, where he participated enthusiastically in a mixed public bath, and after two months of hurried travel, arrived in Marseilles just in time to join a revolution against the Third Republic. Once he saved himself from a firing squad by wrapping his body in the flags of France and the United States; once he was arrested for revolutionary activity; finally he was kicked out of the country. Train did not count the two-month interruption in France; upon his return, he gleefully told American newsmen that he had gone around the world in eighty days. Not long afterward, a French novelist named Jules Verne read of the trip and had an idea for a book. To his own subsequent delight, George Francis Train became the immortal Phileas Fogg.

Twenty years later, Train made the voyage again—this time in sixty-seven days—and in 1892 "eclipsed all previous records" by making it in sixty days flat. As Train put it, these trips were "typical of my life. I have lived fast. I have ever been an advocate of speed. I was born into a slow world, and I wished to oil the wheels and gear, so that the machine would spin faster and, withal, to better purposes." Even his autobiography was done in jigtime; at the age of seventy-four, a year before he died, he dictated it in thirty-five hours.

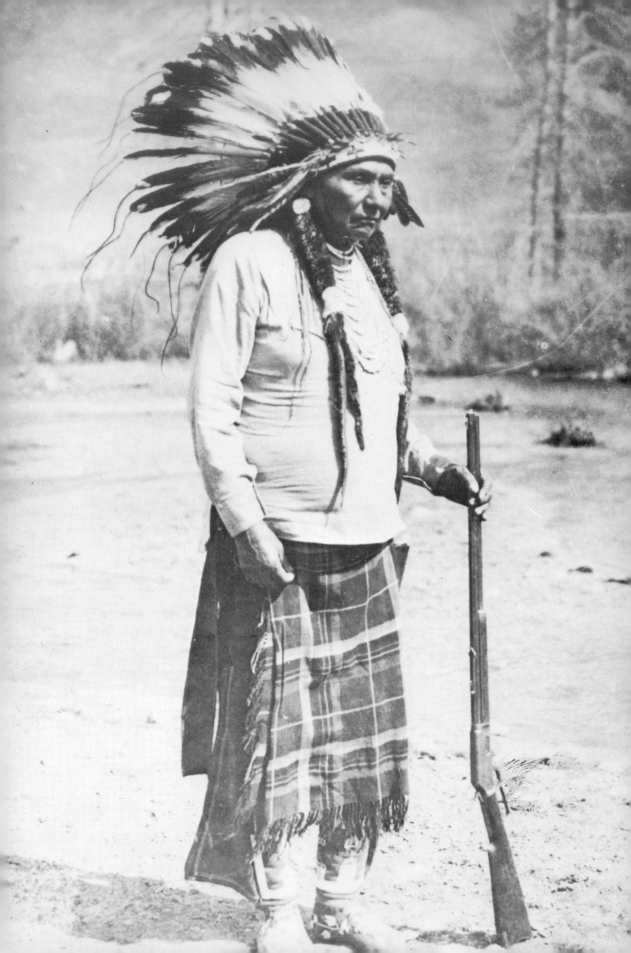

It was ironic that the picture of the chief, taken just a year before his death, should have been made on the occasion the whites called Independence Day. If there was one national holiday without meaning to an Indian in 1903, July 4 was it. Joseph, the great Nez Percé statesman and chief, had come to a gathering of his exiled tribesmen on the Colville Reservation in Washington, and there the photographer T. W. Tolman found him — a brokenhearted yet not quite beaten leader of a proud people, his head bowed, his eyes turned away from the camera, his face a summary of all that had happened to the red man since the whites had come to the Americas four centuries earlier.

Joseph was thirty-six years old when the end began for the Nez Percés. In the year of the Custer massacre, the Indian tribe that had lived in peace and friendship with the whites since the arrival in the Northwest of Lewis and Clark in 1805 was being pushed from the lush grasslands of the Wallowa Valley in northeastern Oregon by settlers. The fundamental difference between them was that the Indians thought of the land, with a mystical reverence, as their mother — the body from which all men had come and to which all would return; the whites considered it only as soil to be plowed, as ground to be grazed by cattle and sheep.

Despite assurances by the Bureau of Indian Affairs and President Grant that the land belonged to the Nez Percés, wagonloads of whites continued to move in; the Indians were increasingly harassed, and finally — in a decision that typified the United States Government's relations with Indians — the tribe was ordered off its land and onto a reservation. Trouble broke out in the process, some young Indians killed a group of settlers, and the United States Cavalry was ordered to herd the hostiles onto the reservation. There began then one of the great military epics of America's history — a thirteen-hundred-mile, four-month retreat by the Nez Percés, in which they alternately eluded

and outfought their tormentors until they were at last run to earth thirty miles from the haven of Canada and defeated in a final, tragic battle. Taking their old men, their women, and their children with them, the Indian warriors had made their way across some of the most rugged, formidable terrain on the North American continent, skillfully outmaneuvering and fighting off units of the Army in six battles, avoiding ambush and hostile white settlers in the area, and facing off exhaustion, hunger, and the growing attrition of fighting men and horses until, on the northern edge of the Bear Paw Mountains of Montana, they were beaten by a vastly superior force.

In one of the most moving speeches of surrender ever made, Chief Joseph stood before General Nelson Miles to say, "I am tired of fighting. Our chiefs are killed. . . . The old men are all dead. . . . He who led the young men is dead. It is cold and we have no blankets. The little children are freezing to death. My people, some of them, have run away to the hills, and have no blankets, no food; no one knows where they are—perhaps freezing to death. I want to have time to look for my children and see how many I can find. Maybe I shall find them among the dead. Hear me, my chiefs. I am tired; my heart is sick and sad. From where the sun now stands, I will fight no more forever."

In the terrible days that followed, days that stretched into years, Joseph and his pitiful Nez Percé followers came to see that the white man had neither mercy nor leniency for Indians. Their captors had promised that they could go home to the land of their fathers, but the promise was broken and they were taken as prisoners of war to Fort Leavenworth, Kansas, to be placed in a malarial river bottom where a score of them, accustomed to the cool mountains of the Northwest, died. Next they were shipped to sandy sagebrush country in Kansas Territory, where nearly fifty more perished. Their next stop was Oklahoma; there more deaths, including that of

Joseph's little daughter, occurred. During all this time, Joseph worked unceasingly to obtain justice for his tribe: a dedicated, tireless spokesman, he pleaded with military men and governors to see the righteousness of his cause. And in 1879 the man whom many Americans were calling the great Indian Napoleon went to Washington to speak to Cabinet members, congressmen, and the President. "It makes my heart sick when I remember all the good words and all the broken promises," he told them. "Treat all men alike. Give them all the same law. Give them all an even chance to live and grow. All men were made by the same Great Spirit Chief. They are all brothers. The earth is the mother of all people, and all people should have equal rights upon it. . . . Let me be a free man—free to travel, free to stop, free to work, free to trade, where I choose, free to choose my own teachers, free to follow the religion of my fathers, free to think and talk and act for myself. . . ."

Throughout the nation, sympathy for the Nez Percés grew, and with the support of individuals and friendly groups in the East, public opinion finally forced the return of the Indians to the Northwest. But not to their own land: four towns stood in the Wallowa Valley when Joseph saw it again, and there were farms and ranches where his people had lived for so long. Joseph made repeated efforts to resettle his tribe in the Wallowa, but each was rebuffed. No one would even sell the land to the Indians. And when he went for the last time to visit his father's grave, his eyes filled with tears, and he went once more to ask the whites to reconsider. No, they told him, the new residents of Wallowa wanted the Indians out of there—forever.

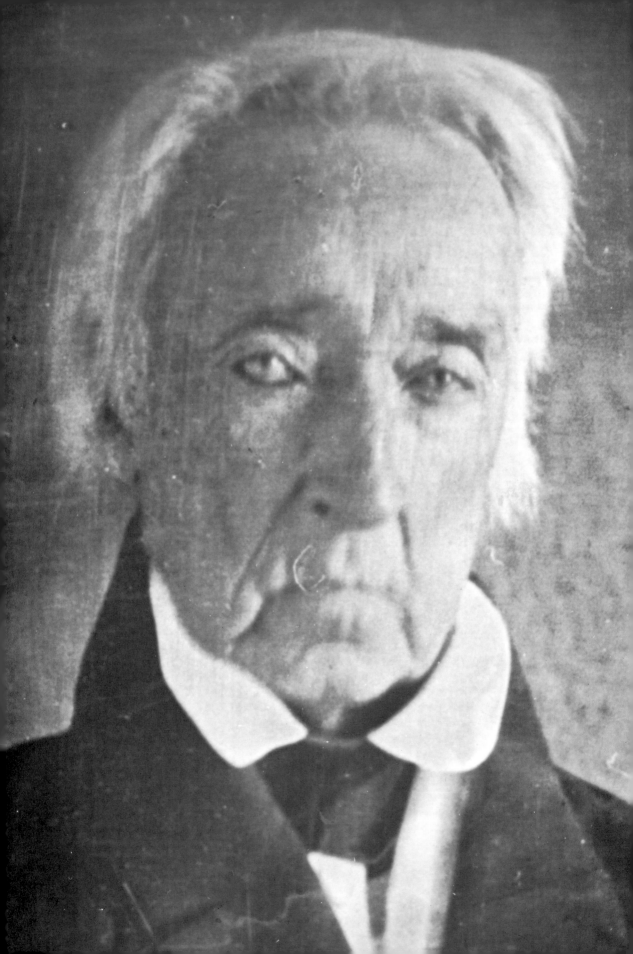

Looking out from a daguerreotype made a century and a quarter ago is a Revolutionary War veteran who was almost certainly born before any other American of whom we have a photograph. It is a curious fact, but the years have not been kind to our Revolution. These days we think of it as a pageant, a wax museum, in which wooden figures in wigs and funny costumes stand on a shadowy stage speaking stiff, archaic lines. But a century and more ago, as Americans moved restlessly out across their new land, the national folk memory that went with them was the war for independence. The Revolution was the communal heritage, and wherever men gathered to discuss the present and the future, the talk inevitably turned to the past and to that golden time that had produced the nation.

The passing years, it was true, had drawn a misty curtain across many of the facts—garrulous old men, trading on longevity, boasted of having done far more than truth could allow; and in telling tales of patriot giants and heroic deeds, they tended to forget the horror, the terrible suffering and cruelty, the discomforts, unrelieved boredom, and bad food that have been the stuff of all wars. Long years afterward, it was easy to forget that not all Americans had been infused with the spirit of '76: perhaps no more than one third of them were active patriots; another third loyalists; while as many others remained silent, uncommitted. At the war's outset, there were some two and a half million people in the colonies—enough to have produced an army of six or seven hundred thousand men; yet in the rebellion's darkest hour, before the desperate gamble at Trenton, George Washington estimated that in a week's time the American "Grand Army" would consist of fourteen hundred men. And in all the subsequent self-congratulation at having vanquished the tyrant George III, Americans lost sight of the fact that they had experienced a civil war of sometimes devastating brutality.

And yet, for all the forgetting and the embellishment,

there it was—the event that had given birth to the nation and bequeathed a common purpose to an incredibly various people. So it was inevitable that the photographer Mathew Brady, whose ambition it was to assemble a collection of pictures of the most famous citizens of his day and publish it as a *Gallery of Illustrious Americans*, should have sought out the only notable veteran of the war who was still alive in 1844. (A handful of other pensioners survived, but none was a man of any special note.) On a trip up the Hudson Valley to take the likenesses of Washington Irving and Martin Van Buren, Brady called at the house of Major John R. Livingston and asked the old gentleman to sit for a portrait by the daguerreotype process. The major agreed, although the expression on his face seems to indicate that he may have acquiesced as a matter of courtesy, not with the idea that anything much would be gained by it.

Behind those faded old eyes were memories going back to the French and Indian Wars and to life in a family that was one of the most illustrious in the colonies. Clermont, where John was born on February 13, 1755, was the manor house on his father's thirteen-thousand-acre estate; this was only a small corner of a vast fiefdom controlled by the Livingston family, a tract that extended from the east bank of the Hudson to the Massachusetts boundary. John Livingston's grandfather, who lived until 1775, had grown up during the reign of Queen Anne, and was said to be a liberal thinker who favored separation from England; John's father, the judge of the Royal Provincial Court of New York, lost his appointment to the King's Bench because of his political sympathies. A member of the Stamp Act Congress, he foresaw troubled times ahead: "Every good man," he wrote in 1775, "wishes that America may remain free. In this I join heartily; at the same time I do not desire that we should be wholly independent of the mother country. How to reconcile these jarring principles, I profess, I am altogether at a loss."

Few families contributed more to the cause than the Livingstons: John's brother Robert was chairman of the committee that drafted the Declaration of Independence (years later, as Chancellor of New York, Robert administered the oath of office to the first President of the United States; as Minister to France he negotiated the Louisiana Purchase; and it was he who financed Robert Fulton's experiment with a steamboat, the *Clermont*, named for the Livingston estate). Another brother, Henry, was an officer during the war; three of John's sisters married generals in the Continental Army. But there was more to it than that: in 1777 a British raiding party burned Clermont; in 1780 Robert informed a friend that their taxes for the year exceeded £100,000 and that ". . . we have no money left of any kind amongst us."

John Livingston served in several capacities during the war. He was variously a purchasing agent for Congress, a manufacturer of cannon and gunpowder, and a major of the Livingston Manor Regiment. From a letter he wrote, we learn that he put down a mutiny of the Manor Regiment, but beyond that, one of the few passing references to his military career is a charge by Judge Thomas Jones, the crusty loyalist who wrote a history of New York, that John and two companions "murdered" a British grenadier officer during the Battle of Princeton.

In his later years Major Livingston became a merchant in New York City and eventually retired to a country home in Red Hook, in the Hudson Valley, where — the last survivor of his family — he died in 1851 at the age of ninety-six. Brady's daguerreotype, tucked away in a box with other family trinkets, was forgotten for a hundred years. Then it was sold by heirs of the family and finally came into the possession of the present owner. Reproduced here for the first time, it is the only known photograph of a Revolutionary veteran of prominence, a man who was already twenty years old when the first shots broke the morning silence on Lexington green.

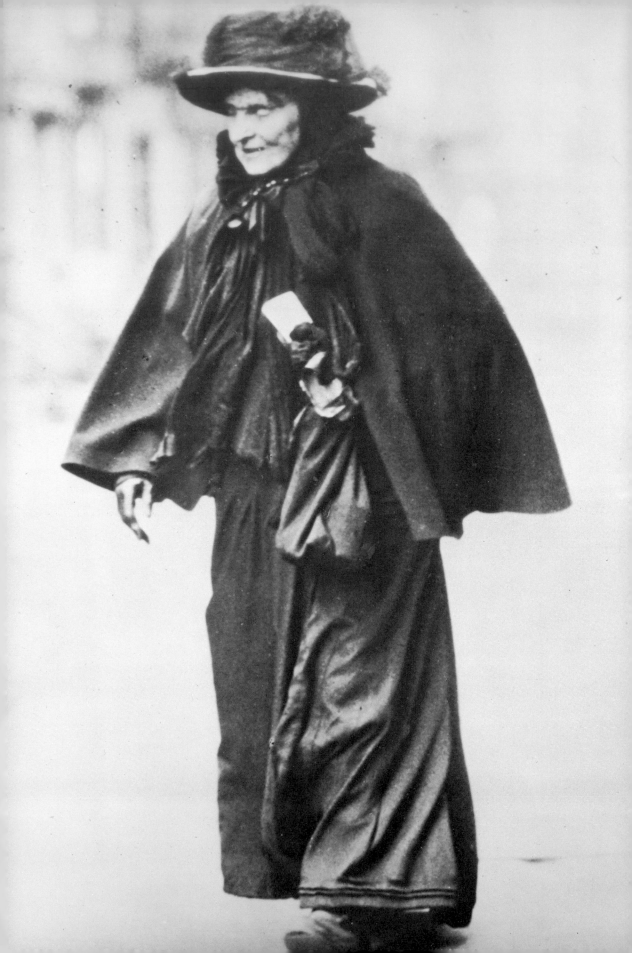

Almost every day the strange figure, swathed in ancient black, might be seen walking down the street toward the Chemical National Bank. There she went directly to the vault, pulled out the trunks and bags that were stored for her under a staircase, and sat cross-legged on the floor rummaging through the masses of papers and documents that represented her fortune of more than fifty million dollars. Her hands and face became smudged with dirt while she clipped coupons from a great pile of bonds and put them into a basket at her side. This work was too important to be interrupted by lunch; when she was hungry she reached into a pocket of the black dress and drew out an unwrapped ham sandwich. Beneath the folds of that garment she wore a petticoat in which were sewn a number of deep pockets, each big enough to hold the contents of a safe-deposit box (one day she arrived at the bank carrying $200,000 in negotiable bonds); beneath the petticoat, on a cold winter's day, were newspapers that she had fashioned (after reading) into extra underclothes. Around her waist was a chain from which hung keys to safe-deposit boxes all over the country; in New York City alone, in addition to the space so generously allotted her at the Chemical National, she had eleven boxes at the Safety Deposit Company.

In the early 1900's America had an unusually colorful grade of millionaire, but Hetty Green—the Witch of Wall Street—had more eccentricities than most. During those years when Vanderbilts, Belmonts, Goulds, Astors, and others were building lavish palaces, putting their riches on display, Hetty Green was living under a variety of assumed names in a series of cheap boarding houses in order to save money and escape the tax assessor. One fall she took a room in Far Rockaway; it was several hours from the city by ferry and train, and she had to wear fishermen's boots for the walk to the station through the sand, but since it was out of season the rent was only five dollars

a week. Sometimes she had a room in the Bowery, or a third-floor-rear hall bedroom in Brooklyn, or a walk-up in Harlem (there was no icebox and her meat spoiled—a loss she complained about for years). Often she spent only one night at a place, arriving with so little luggage that landladies asked her to pay in advance. She was living in Hoboken, New Jersey, under the name of Dewey (her dog's name) when officials discovered who she was and learned that the dog was unlicensed. When they tried to collect the two-dollar fee she moved to a friend's apartment in New York. Although she hated lawyers (she got a license to carry a revolver to protect herself against them), she used them constantly: she went to court, it was said, "like other women go to the opera."

Once she boarded a streetcar and gave the conductor half a dollar. He looked at the coin and handed it back; it was counterfeit. She had no more money in her pocketbook, but a postman who was on the car recognized her and vouched for her credit. A few days later she appeared at the trolley company office, put a nickel on the counter, and held her finger on it until she was given a receipt. This happened at the same time that she was loaning the City of New York $4,500,000.

Hetty Robinson began accumulating money in 1865, when she inherited from her father about a million dollars outright and a life interest in five million more. Two weeks later her aunt died and left her a life interest in a residuary estate of nearly a million dollars (Hetty tried to break the will, claiming she should have her aunt's entire fortune). In 1867 she married Edward Green, who was himself worth over a million dollars, and by 1885 her capital had grown to $26,000,000, largely as a result of his skillful management. But that year he committed the unpardonable sin: he lost all his own money speculating, and she had to cover some of his debts. Eighteen years of marriage were no compensation; she was through with Edward Green, whose worldly possessions just then con-

sisted of seven dollars and a watch. "My husband is of no use to me at all," she said. "I wish I did not have him. He is a burden to me." From that day on they lived apart, and she managed her own money. It is hard to see how anyone could have done better.

She loved a good panic. "I believe in getting in at the bottom and out at the top," she observed. She also loved six per cent interest and her two children, in that order.

When Hetty Green's son, Ned, was fourteen he dislocated his kneecap in a sledding accident, and rather than spend any money on a doctor his mother looked after the boy herself. Two years later he was still suffering severe pain, so she took him to a New York physician— they appeared at his office disguised as beggars. After several treatments the doctor discovered that she was Hetty Green and asked to be paid. She never went back. And three years later Ned Green's leg had to be amputated. Yet in her way she did all she could for him. To give him a start in business she sent him to Chicago to oversee her real-estate holdings there. Each month the young man relayed to his mother $40,000 in rents, and in return she paid him an allowance of $3 a day (she started him at $6 but cut it back when she learned he was spending some on himself). Later she bought him a Texas railroad, and now and again sent him an unsigned telegram telling him what to do. Young Green always knew the source: they came collect.

When Hetty Green died in 1916 at the age of eighty-one, she left her son and daughter an estate worth over one hundred million dollars. She also left a reputation about which she knew she could do nothing. "I do not blink facts," she had said; ". . . my life is written for me down in Wall Street by people who, I assume, do not care to know one iota of the real Hetty Green. I am in earnest; therefore they picture me heartless. I go my own way, take no partners, risk nobody else's fortune, therefore I am Madame Ishmael, set against every man."

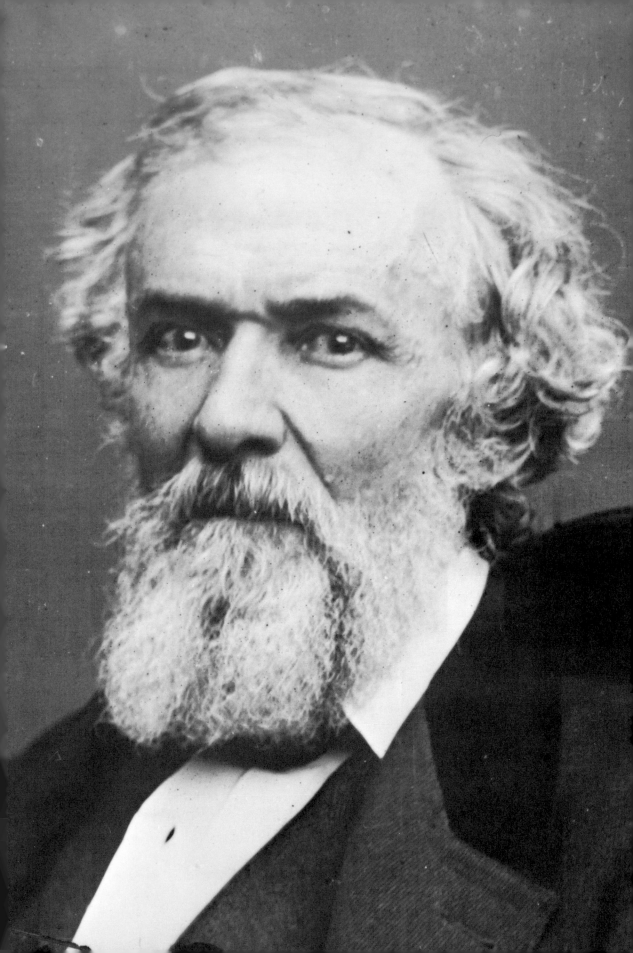

There were signs, by April, 1847, that the
Mexicans might be willing to sue for peace,
and in Washington President James K. Polk
concluded that he should have a peace com-
missioner with the American Army, ready
for any eventuality. Who it might be was something else
again; as eager as Polk was for peace, he had no desire to
appoint a man who would make political hay out of the
important mission.

So the choice fell upon the relatively unknown chief
clerk of the State Department, Nicholas P. Trist—a man
whose face matched the sadness of his name. Trist came
from a good, but impoverished, Virginia family; he had
polished manners, high intelligence, a broad knowledge
of world affairs, and his connections were the best. He had
studied law with Thomas Jefferson and married the great
man's granddaughter. He had been an executor of Jef-
ferson's will and had later become Andrew Jackson's
protégé and private secretary, so his credentials as a
Democrat were impeccable; what was more important to
his task, he was "perfectly familiar with the Spanish
character and language."

As he headed for Mexico, a "commissioner pleni-
potentiary" bearing secret orders and a letter signed by
the President of the United States, Trist took the precau-
tion of disguising himself as a Dr. Tarreau, French
merchant; but he had not reached New Orleans before an
account of his mission was published "with remarkable
accuracy & particularity" in several newspapers, at once
undermining Polk's confidence in his agent. After arriv-
ing at Vera Cruz, Trist immediately succeeded in offend-
ing the thin-skinned General Winfield Scott by failing to
inform him fully of his mission, with the result that it was
two months before the United States peace commissioner
and the commanding general of the United States Army
spoke to each other. Between them, Polk noted acidly,
"the orders of the Secretary of War & the Secretary of

State have been disregarded . . . and the golden moment for concluding a peace with Mexico may have passed." Fortunately for the future of the two countries, the two men finally began corresponding civilly, and when Scott, learning that Trist was ill, sent the State Department man some guava marmalade, the breach was healed.

After his first meetings with the Mexican peace commissioners, Trist submitted to Washington a boundary proposal that differed from the one he had been authorized to get. Angrily, Polk ordered Trist recalled, and he was infuriated when Trist responded with a sixty-five page letter explaining his refusal to come home. "His despatch," Polk wrote, "is arrogant, impudent, and very insulting to his Government, and even personally offensive to the President. . . . He has acted worse than any man in the public employ whom I have ever known." Meanwhile, Trist had taken the further liberty of actually signing a treaty with the Mexicans on February 2, 1848, at a place called Guadalupe Hidalgo, outside Mexico City. Refusing to permit a sudden opportunity for settling the war to slip away, Trist had ignored his orders to return home and had proceeded on his own; realizing that the boundaries included in his original instructions were the maximum to which the Mexicans could agree, he had incorporated them into the treaty. Despite his dudgeon, President Polk decided to accept the document and submit it to the Senate, since it conformed substantially to what he had wanted in the first place; but he never forgave Trist for his insubordination. After some debate and the addition of minor modifications (including a preamble criticizing the irregular behavior of Nicholas P. Trist), the Senate ratified the treaty.

Under its terms, the United States-Mexican border became the Rio Grande, and the nation's destiny was made manifest by acquisition of all the territory between that river and the Pacific—the present states of California, Nevada, Utah, New Mexico, Arizona, part of Wyoming,

and the west slope of Colorado. Excepting the Louisiana Purchase, it was the largest acquisition of territory made by the United States, and it gave Polk the distinction of adding more land than any other President but Jefferson. Unbeknownst to Trist or the government, in the same week he signed the treaty, gold was discovered in the Sacramento Valley, making Trist's achievement even more lucrative than anyone could have foreseen.

But Nicholas P. Trist was to derive neither fame nor honor nor riches from his incredibly fruitful labors. He was put under arrest in Mexico by the United States Army and forced to leave the country; returning to Washington, he found that he was dismissed from government service and disgraced. Polk could not bring himself to forgive Trist's act of disobedience, and in fact saw to it that Trist never even received his full pay for the mission; his salary was cut off as of the date of his recall. Trist pleaded his cause in a memorial to Congress, but Congress, like the President, was unforgiving.

Nearly destitute, the Trists moved to Pennsylvania where, for seven years, they eked out a livelihood. Trist was reduced to taking a job as a clerk for the Wilmington and Baltimore Railroad Company, eventually working his way up to paymaster at a salary of $112.50 a month. In that position the confidant and friend of Jefferson, Madison, and Jackson remained until 1869, when his health was no longer up to it. For years his old friends had tried to persuade Congress to redress the injustice done Trist; fortunately, action came in the nick of time, in 1870. After an eloquent speech in his behalf by Senator Charles Sumner, Trist was awarded the sum of $14,559.90, the money owed him for his salary and expenses in Mexico twenty-three years earlier. And that summer President Grant appointed him postmaster in Alexandria, Virginia — a job he held until his death four years later — at a salary of $2,900 a year. It was more money than sad Nicholas Trist had made at any time since 1841.

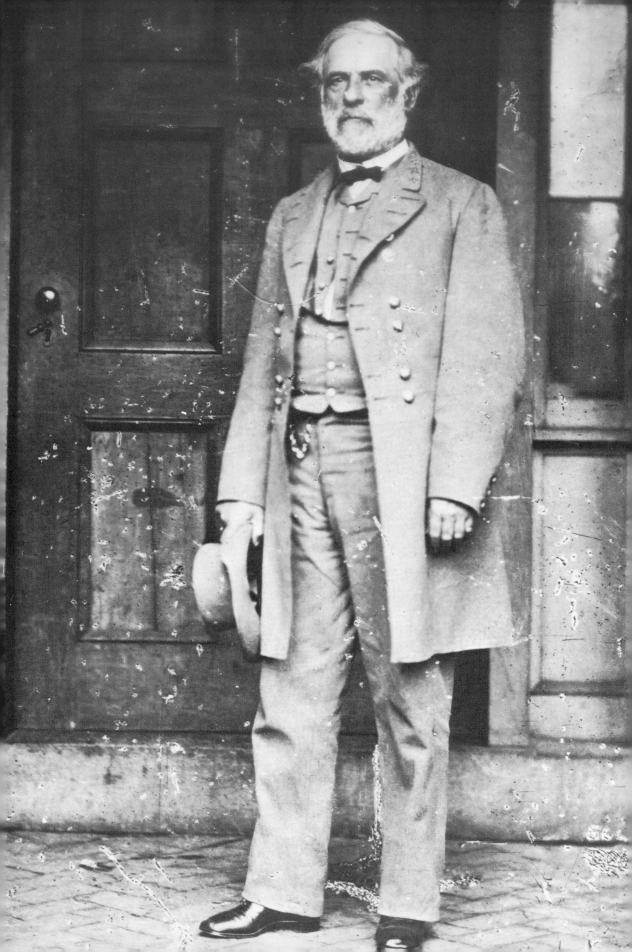

The ordeal in Wilmer McLean's parlor took place on April 9, but Robert E. Lee remained near Appomattox for another three days, until his men stacked their arms and surrendered the worn, faded battle flags which they had followed for four years. Then he set out toward Richmond, pitching his tent each night, sleeping under canvas for the last time. News of his coming preceded him, and along the road women and children waited, some with gifts of food.

On the morning of April 15, 1865, at almost the same time that Abraham Lincoln was dying in Washington, Lee reached the town of Manchester on the outskirts of Richmond. William Hatcher, a Baptist minister, looking out his window at the gray, sodden landscape, saw Lee's party ride by in the heavy downpour. "His steed was bespattered with mud," Hatcher wrote, "and his head hung down as if worn by long traveling. The horseman himself sat his horse like a master; his face was ridged with self-respecting grief; his garments were worn in the service and stained with travel; his hat was slouched and spattered with mud. . . ."

The rain was still falling when Lee and five other officers, with Lee's old ambulance and a few wagons carrying their personal effects (one, lacking canvas, was covered with an old quilt), rode into Richmond, and the first people who saw them enter the ruined city wept. As they went along, crowds grew thicker, cheers broke out, and Union troops uncovered when the General passed by. Finally he reached the house on East Franklin Street, dismounted, and made his way toward the gate through a cheering throng, occasionally grasping an outstretched hand. Then he bowed, went into the house, and closed the door on four years of war.

Worn out, heartbroken, deeply concerned for the future of the South and its people, Lee stayed in the house for days on end, sitting quietly in the back parlor with his

family, sleeping the sleep of exhaustion. In those first weeks after Appomattox, Union troops patrolled the streets of the city outside his door; dazed civilians depended for food on handouts from Federal relief agencies. No trains entered the ghostly city; there was no mail. Yet everyone waited for news, mostly to learn the fate of captured troops or of the army still fighting under Joe Johnston. Nearly fifty thousand Negroes had come in from the outlying plantations, but no one seemed to know what to do with them, or they with themselves. After Lincoln's assassination former Confederate soldiers were forbidden to talk to each other in the streets, and between ten and fifteen thousand of them roamed the city, silent, sullen, many of them crippled. At night the desolate city was in darkness, for fire had destroyed the gas mains. There was no light, and there seemed to be no hope.

If Lee had thought to shut out the city and the past he was mistaken, for the South still looked to him for leadership, despite the Union sentinel in front of his house. A stream of callers began to arrive: women seeking husbands and sons, ministers and civic leaders seeking advice, the curious seeking souvenirs or a glimpse of the great man. Confederates still in Libby Prison wrote, asking him to arrange their release, or if that was impossible, just to "ride by the Libby, and let us see you and give you a good cheer. We will all feel better after it." Officers and men came by to bid their old chief farewell before they headed for home. One day two ragged soldiers appeared, saying they were delegates for sixty more whose uniforms were too tattered for them to enter the house. On another occasion, when Lee was trying to answer the flood of correspondence, a tall Confederate soldier with one arm in a sling came to the door and was turned away with an apology by Custis Lee, the General's son. As he turned to go, the soldier said he had been with Hood's Texans and had followed Lee for four years, and now he was going to walk home to

Texas; he had hoped to shake his commander's hand. Custis changed his mind and went to get his father, and when Lee came downstairs the soldier took his hand, struggled to say something, and then burst into tears. He covered his face with his arm and walked out of the house.

Thousands who could not see him in the flesh wanted a picture, and one day in April Mathew Brady, the photographer, came to the front door and told a servant he wanted to see the General. When Lee appeared and heard the request he said, "It is utterly impossible, Mr. Brady. How can I sit for a photograph with the eyes of the world upon me as they are today?" But Brady, who had suffered physical and financial hardships and risked danger on a score of battlefields in his determination to document the Civil War, knew this was one picture that had to be taken. It ended the story.

He went to Mrs. Lee and to one of Lee's friends, and they persuaded the General to sit for him. Once more Lee put on the gray uniform, came out into the sunlight below the back porch, and spoke wearily to the photographer: "Very well, Mr. Brady, we are ready." And the photographer with the failing eyesight put his head under the black cloth, focusing the camera until he thought he could see the image sharp. His subject, the commander in chief of the defeated Confederate Army, stood motionless, perfectly controlled except for the pride and defiance written in his eyes.

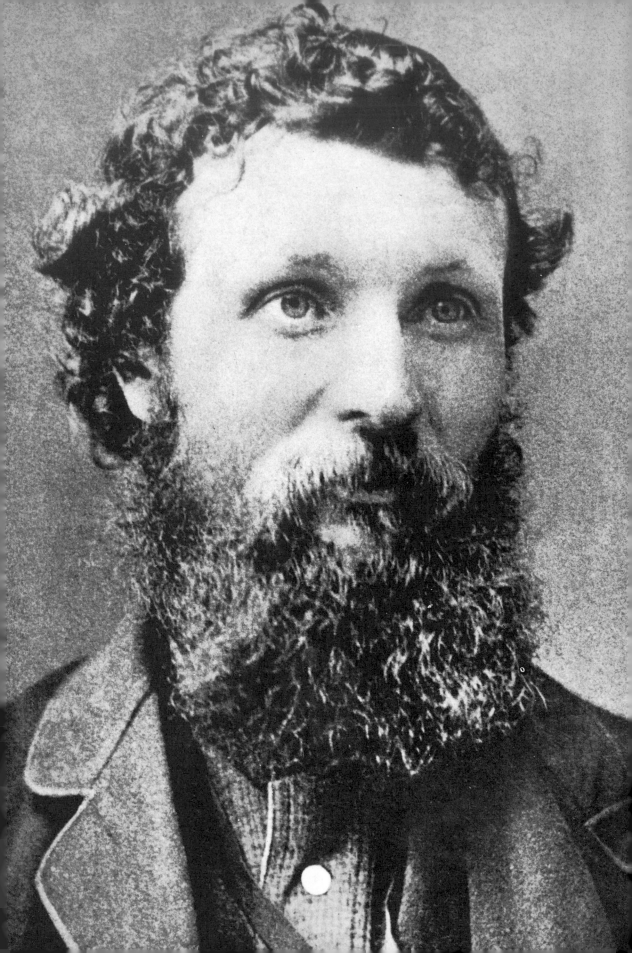

I might have become a millionaire," he once said, "but I chose to become a tramp." As a boy in Scotland, he had thrilled to descriptions of primeval America, to John James Audubon's picture of passenger pigeons that "darkened the sky like clouds"; and fifteen years later in Wisconsin, on a March morning when the wild geese were heading north on the first warm wind, he said good-by to his family and wandered away. He wanted to experience the wilderness, "not as a mere sport or plaything excursion, but to find the Law that governs the relations . . . between human beings and Nature." It was a quest that lasted all his life.

In the manner of other families, John Muir's tried to persuade him to go into business, to marry, to settle down, but he had already concluded that "civilization has not much to brag about," and he wanted none of it. On his first wander, when he was twenty-five, he settled into a pattern he would follow for years: he took a "planless route," preferring to whirl "like a leaf in every eddy, dance compliance to any wind." He walked, it was said, with a stride like an Indian's, moving quietly and swiftly, his eyes on the ground so that he would miss nothing, pausing now and again to examine a rock or an unknown flower through his glass. He was a natural climber (one friend said he moved up mountains like a human spider) and seldom halted until he reached the top. Totally unafraid—of danger, of loneliness, or of death—he never carried a gun, and usually he went for the better part of a day without food; the great staple of his diet was hard, thick-crusted bread, or oatmeal cooked in little cakes on the stones of his campfire, with some tea (all he had to do to get ready for an expedition, Muir said, was to "throw some tea and bread in an old sack and jump over the back fence"). He especially loved swamps—his Highland blood flowed bogward, he believed. And as he hiked, observing everything, contemplating the history of mankind along with the wilderness, he realized that to disturb the balance

of nature was to produce flood or drought, as to upset the balance of human society was to produce war. The only course to follow, he concluded, was the universal law of co-operation. "I never tried to abandon creeds or code of civilization," he said; "they went away of their own accord, melting and evaporating noiselessly without any effort and without leaving any consciousness of loss."

Between these early rambles, John Muir drifted from one job to another, picking up enough money to enable him to travel again or to study, and leaving behind, wherever he paused, a trail of ingenious inventions and laborsaving devices. Even before he left home, he had built, with a few coarse tools brought from Scotland, a small sawmill with a double rotary saw; a "field thermometer" that could be read from nearby pastures, so sensitive that it recorded the slight changes in temperature caused when a person approached within a few feet of it; a number of remarkable clocks (one, made mostly of wood, struck the hours, indicated the date, started the fire in his stove and lit his lamp, and—by means of some intricate levers and cogwheels—upended his bed at the appointed hour in the morning). But at no time would John Muir take out a patent or capitalize on his ingenuity; all improvements and inventions, he believed, were the property of the human race, since every idea was inspired by the Almighty.

In 1867 an accident in a mill cost him the partial sight of one eye, and he decided then to give himself fully to the wilderness. With Emerson, he had to be true to himself, and he realized that he could have no real happiness away from nature. "As long as I live," he wrote, "I'll hear waterfalls and birds and winds sing. I'll interpret the rocks, learn the language of flood, storm, and the avalanche. I'll acquaint myself with the glaciers and wild gardens, and get as near the heart of the world as I can." And after a 1,000-mile walk from Indiana to the Gulf of Mexico, he went, finally, to California, where he found his

way inevitably to Yosemite Valley, the "most holy mansion of the mountains." For years he roamed the Sierras, the Pacific Northwest, the Alaskan wilds, climbing, observing, measuring the movement of glaciers, exulting in the primitive glories of everything he saw. And then, in the seventies, the loggers moved into the great sequoia stands as they had swarmed into the pine and hardwood forests of Wisconsin, and Muir realized that if something were not done, the big trees would go forever. He saw speculators and railroads picking up land and water rights, sheep and cattle moving into the valleys, and his heart went out to "the thousands needing rest—the weary in soul and limb, toilers in town and plain, dying for what these grand old woods can give." He determined to make the wilderness better known, so that future generations would cherish it as he did and preserve the great watershed forests. From then until the end of his life, in 1914, he worked incessantly to save his beloved wilderness, writing, lecturing, inspiring, persuading. His first triumph came in 1890, when the Yosemite National Park bill was passed, followed by creation of the Sequoia and General Grant National Parks. Other fruits of his work were the National Park Service and the Bureau of Forestry; and upon his advice the Petrified Forest and a portion of Grand Canyon were set aside as national monuments. But it was plain that only the most determined and continued efforts would stave off despoliation of America's natural heritage. The last years of his life were spent in a valiant but unavailing fight against the plan to dam the beautiful Hetch Hetchy Valley.

After every trip to the "dead pavements" of the city, John Muir hurried back to the mountains, shouting, "I'm wild once more!" He was a man to whom every leaf spoke, whose lifelong devotion to nature he described in his journal: "I only went out for a walk and finally concluded to stay out till sundown, for going out, I found, was really going in."

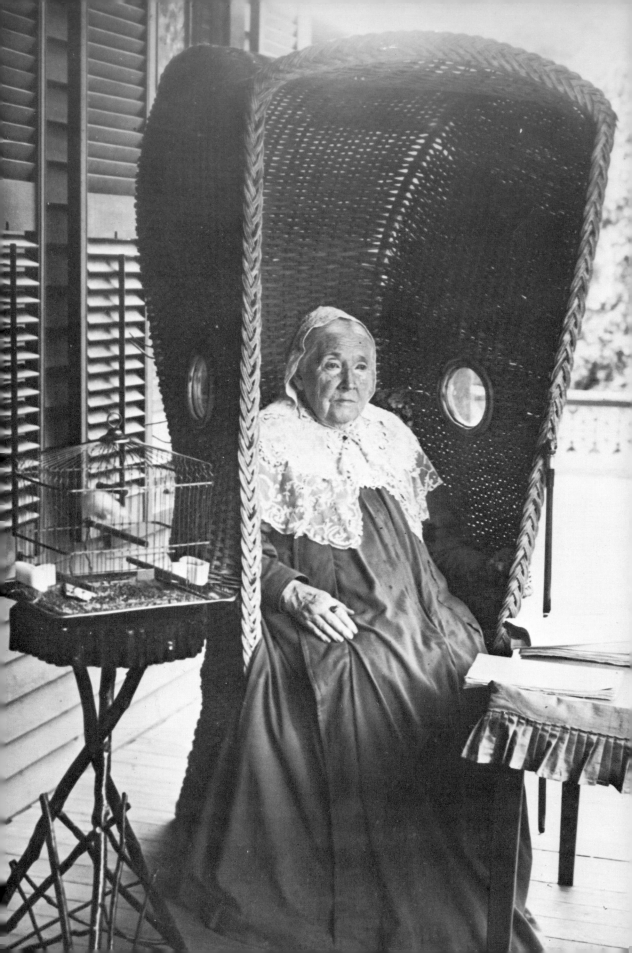

B efore her death at ninety-one, she could look back on as full and rich a life as few people are privileged to have. She had begun it as a beautiful, gifted girl from a wealthy New York family; she had a lovely singing voice, she became a poet, playwright, and well-known wit. At the age of twenty-four she married a hero of the Greek war for independence, the humanitarian Samuel Gridley Howe, who turned to the teaching of blind children and who, with the outbreak of the Civil War, played a leading role in creating the United States Sanitary Commission, forerunner of the American Red Cross. By 1905, about the time this photograph was taken, Julia Ward Howe was the most prominent woman and surely one of the best-loved in America. She was still active in the woman's suffrage movement and other causes, she was much sought as a speaker; but it was the song she had written that caused people to leap to their feet and applaud whenever she appeared on a platform.

Before the Civil War, America's popular music consisted mostly of hymns, minstrel songs, and a few European melodies, and as the war brought men together in unfamiliar circumstances, far from home, music filled a common need, and those earlier tunes were adapted as camp and marching songs. One popular southern revival hymn of the 1850's, written by William Steffe, was "Say, Brothers, Will We Meet You Over on the Other Shore?" The hymn made its way north, and in 1861 a group of soldiers in the Twelfth Massachusetts Regiment, stationed at Fort Warren, made up some new words as a joke on one of their buddies, John Brown. "John Brown's Body," they called it. When the regiment boomed it out while marching through New York City on their way south, the crowds went wild; everyone who heard it assumed, quite naturally, that the John Brown of the song was the man who had been hanged in 1859 after his raid on Harpers Ferry.

Late in 1861 Julia Ward Howe heard troops in Washington singing the John Brown song, and a friend asked her, "Why don't you write some good words for that stirring tune?" She was staying at the Willard Hotel, and the next day she awoke in the gray of the morning twilight; as she "lay waiting for the dawn, the long lines of the poem began to twine themselves" in her mind. She got up, found an "old stump of a pen," and—so as not to forget the words—began writing them on the letterhead of the Sanitary Commission. It seemed to her then, and later, that the words had come to her in a strange and marvelous way, from some source outside herself. In her original manuscript she changed only four words, and deleted one stanza that altered the poem's climax. Fortunately, she recorded the lines; after doing so she went back to sleep again, and when she awoke found that she remembered what had taken place but had forgotten the words. Later she sent the poem to the *Atlantic Monthly*, where it appeared in February, 1862, and was "somewhat praised." The editors sent her a check for four dollars.

It is not clear when or how the Union troops began to sing what Mrs. Howe called "The Battle Hymn of the Republic," but an Ohio chaplain named Charles McCabe, who had read the poem in the *Atlantic Monthly* and memorized it, taught it to his regiment and they sang it to the old hymn tune as they marched off to war. McCabe was captured and sent to Libby Prison, where he and hundreds of Union soldiers, jammed together in a huge room, learned of the great victory at Gettysburg. They jumped to their feet and cheered, and the chaplain, who had a good baritone voice, began to sing, "Mine eyes have seen the glory of the coming of the Lord," while every northern man in the prison joined in the grateful chorus: "Glory, glory, hallelujah!" Later McCabe was exchanged, and at a rally in Washington attended by the President, he described his experience before singing the song again. "The effect was magical," Julia Ward Howe was told; "people

shouted, wept, and sang together . . . and above the applause was heard the voice of Abraham Lincoln, exclaiming while the tears rolled down his cheeks, 'Sing it again!' "

Three and a half decades passed, and a Civil War memorial was being dedicated in Boston. A Philadelphia reporter covering the event wrote, "It was away over any similar celebration I ever saw. . . . I never imagined possible such genuine sweeping emotion as was awakened by the singing of the 'Battle Hymn of the Republic.' I always knew it to be the greatest thing of its kind ever written, but it never had a fair chance before. . . . There was the packed, still house. Myron W. Whitney started to sing. First he bowed to the box and then we first recognized Mrs. Howe. . . . You should have heard the yell! . . . You could see the splendid white head trembling; then her voice joined in as Whitney sang: 'In the glory of the lilies Christ was born across the sea,' and by the time he reached the words, 'As He died to make men holy, let us die to make men free,' the whole vast audience was on its feet sobbing and singing at the top of its thousands of lungs."

The revival hymn, the John Brown song, had been transformed into an expression of the national faith by Julia Ward Howe. Her words made it a soaring American hymn to the God of the Jews and the Puritan fathers, the God of truth and righteousness who led His soldiers into battle and to triumph over evil. This was a song men could march to and sing at the top of their lungs—a spine-chilling hymn to hear when it was sung by massed voices—a song to bring tears to the eyes and to tear at the heart, a song to inspire. In the final verse was the pledge that had called, and would continue to summon, Americans to battle in every war the nation had fought: "let us *die* to make men free." If there was one article of faith to which all of them could subscribe, it was represented by that word "freedom"—the ideal that had brought them here from so many different places and backgrounds, the single, unifying vision no man or group could deny.

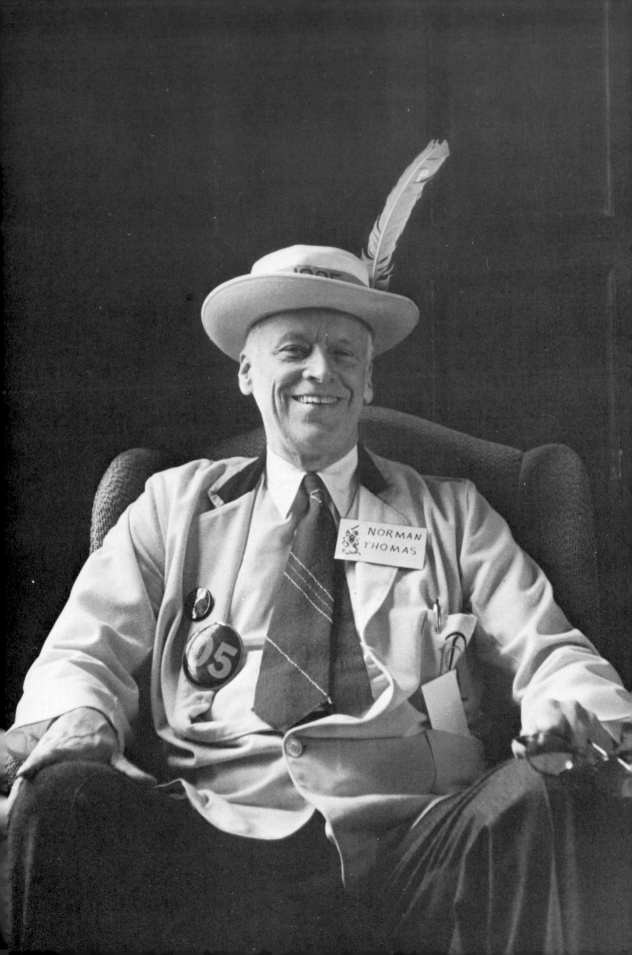

There was a delicious irony to the picture: the man who had run for President of the United States six times on the Socialist ticket, togged out in the reunion costume of a university that had a certain reputation for wealth and privilege and the easy life. He had never wanted any of those things. "I suppose it is an achievement to live to my age," he remarked near the end of his days, "and feel that one has kept the faith, or tried to"; but, he reflected, "as the world counts achievement, I have not got much."

A majority of Americans, refusing to take seriously any third-party candidate or his notions, regarded him with a mixture of perplexity and affection, as they did most underdogs. Every four years he entered the lists again, a lonely knight on a hopeless quest, campaigning so many times people lost count, telling them to "vote your hopes, not your fears." But as the years passed, there was a growing realization that many of the ideas Norman Thomas had advanced as socialism had been adopted in the land of free enterprise, almost without anyone's knowing it. He spent a lifetime pricking the nation's conscience, tugging and pushing it toward his vision of the better road ahead.

Born in 1884 in Marion, Ohio, the son of a Presbyterian minister, he earned his pocket money delivering newspapers—the Marion *Star*, published by Warren Gamaliel Harding. After a year at Bucknell College he transferred to Princeton and graduated valedictorian of the class of 1905. A classmate, recalling "Tommy's" views as "conventional," remembered that "he considered himself a Republican. And for his life work he looked forward to entering the ministry." After college he went into social work, took a divinity degree at Union Theological Seminary, and became a pastor of an East Harlem church. For the five-year record of Princeton's class of 1905, he noted that "my chief interests in life are still religious and social work in the crowded tenement dis-

tricts of the city." But politically, his views had changed.

He came to socialism, he said, "slowly and reluctantly" by way of "ethical compulsion," aroused by his work with the wretchedly poor and his pacifist attitude toward World War I. "War and Christianity are incompatible," he declared, and joined the Socialist party in 1918. At the same time he was active in the organization that became the American Civil Liberties Union, and he remained a tireless advocate of individual rights. By 1924 he entered politics, as the Socialist and Progressive candidate for governor of New York, and when Eugene V. Debs died in 1926 he became the leader of the Socialist party.

None of this activity was without effect upon his personal life. In the twentieth-year record of his college class he called himself "an advocate of unpopular causes," observing that "my path has led me away from the road traveled by many old friends. This I regret, but nothing else." As the Depression struck America, he turned his immense energies to causes brought on by financial catastrophe: he spoke out in behalf of the unemployed, set up a Workers Defense League, sponsored organizations for tenant farmers and sharecroppers, marched in a thousand picket lines, signed a thousand petitions. Four years before Franklin Roosevelt came to power he was advocating old-age pensions and public works, the five-day week, and a system of unemployment insurance; in 1932 his platform also called for low-cost housing, slum clearance, minimum wage laws, and the abolition of child labor. But the New Deal stole socialism's thunder by turning many of those ideas into law. "It was often said," Thomas mused, "that Roosevelt was carrying out the Socialist party platform. Well, in a way it was true—he carried it out on a stretcher." In his opinion, the New Deal was not much more than a device for rescuing capitalism; he didn't like Roosevelt's methods and had many reservations about his programs. But he delighted in recalling a visit he once made to the White House, when F. D. R. told

him, "You know, Norman, I think I'm a better politician than you are"; Thomas would pause for a moment and then add, with a smile that seemed to split his face, "I thought that was a damned obvious thing to say."

For all his radical ideas, he never fell for Soviet-style communism. "I daresay I have denied communism, fought against it, more than most people," he said, "because at my end of the political spectrum one must make it clear that standing for democratic socialism is quite another thing from standing for communism." In his eyes, the battle was between democracy and totalitarianism; it did not embrace class conflict or violent revolution.

His tolerance for adversity was matched by an insurmountable faith in the goodness of man. When one of his sons went off to World War II, he wrote him: "If the Lord must be disappointed in us men and our ways, so must the Devil in the presence of such courage, love, and companionship as plain people show." Outspokenly critical of that war, he was equally vigorous, in his eighties, in condemning the armaments race and the evils of the Vietnam conflict. Until his death he continued to function as the conscience of America, a bony, rumpled ombudsman stabbing home his points with an accusing forefinger, fearlessly challenging every foe of freedom and justice. And the generation that was called young when Norman Thomas was an old man perceived him for what he was.

When the class of 1905 returned to Princeton for its sixtieth reunion, Norman Thomas was there, tormented by a dozen afflictions of the flesh. Arthritic and nearly blind, he marched from Nassau Hall to the baseball field on the arm of his friend Raymond Fosdick, and as the old-timers walked into the stadium the young people in the stands stood up and cheered. "What's going on, Ray?" Thomas asked his companion, "I can't see. Why are they cheering?"

Fosdick turned to his classmate. "Why, Norm, don't you understand? They're cheering for you."

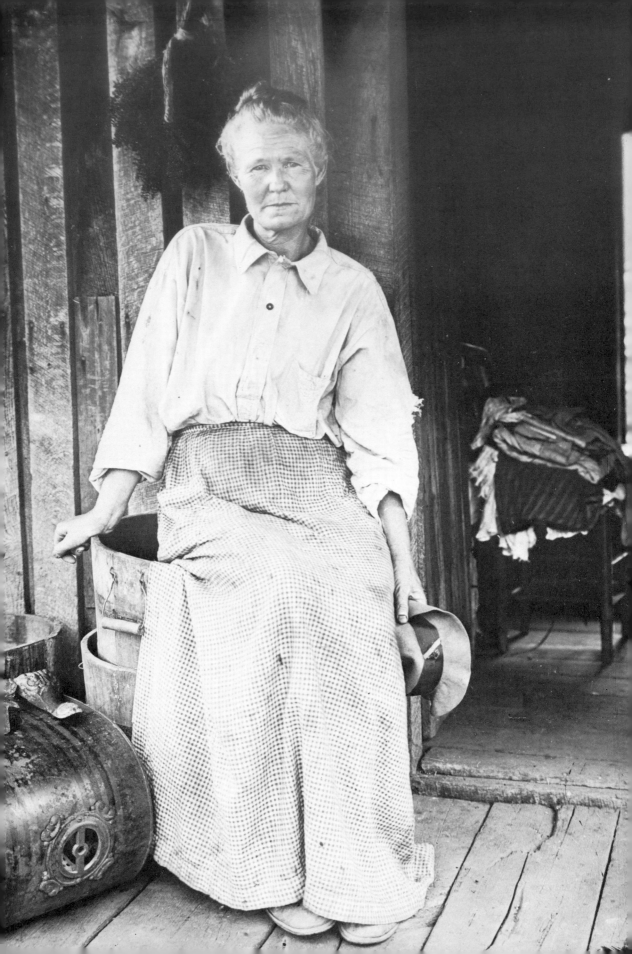

The first summer William A. Barnhill packed up his 5-by-7-inch view camera and glass plates and headed for the mountains of North Carolina, Woodrow Wilson was President of the United States, Henry Ford's Model T was rolling off the Highland Park assembly line in ever-increasing numbers, and Congress had just passed the income-tax amendment to the Constitution. The twentieth century was well into its second decade and America had become a modern nation.

Barnhill's destination, which was nearly equidistant from Detroit and Washington, was as far removed from modern times as it was possible to be in the United States. Western North Carolina lay in the heart of the southern Appalachians—an immense, homogeneous region that sprawled over eight states. It was a territory larger than New England, peopled by some three million Americans of colonial ancestry and predominantly British stock, but of this area the average citizen knew about as much as he did of Zanzibar or Zara.

For two hundred years the forbidding heights of the Blue Ridge, the Cumberlands, and the Unakas had turned back the press of civilization—to such an extent that the people of the Southern Highlands could truly be said, in 1914, to be living as they had in the eighteenth century. Isolated from the mainstream of progress and events for five and six generations, they were very much closer in habit and manner and speech to Daniel Boone than they were to William Barnhill. The radius of the average highlander's environment extended only a few miles from his one-room log cabin: many of them had never seen even a fair-sized town, some had never seen a railroad, others did not know of the existence of Negroes. The mountains within which they lived were so nearly impassable that the inhabitants of one side of a ridge knew as little about those on the other as they did about the residents of another county. Going up these moun-

tainsides, it was said, "you can stand up straight and bite the ground; goin' down, a man wants hobnails in the seat of his pants." And there was the story about a farmer who fell out of his cornfield and broke his neck. One observer, seeing Daniel Boone's famous Wilderness Road for the first time, said, "Despite all that has been done to civilize it since Boone traced its course [in 1775], this honored historic thoroughfare remains as it was in the beginning, with all its sloughs and sands, its mud and holes, and jutting ledges of rocks and loose boulders, and twists and turns, and general total depravity."

William Barnhill made the first of many hiking trips in the North Carolina mountains a year after the publication of Horace Kephart's classic work on the people of the region, *Our Southern Highlanders*. Where Barnhill hiked up and down the miserable roads and mountain trails of the area photographing the scenery and the people, Kephart had done the same with notebook in hand. Both men became residents of the region for a time; between them, a vivid portrait of everyday life in this forgotten pocket of America was preserved.

The endless mountains they saw (comprising nine tenths of the western portion of North Carolina), were old before the Alps, the Andes, the Himalayas, or the Rockies were formed, and were covered almost continuously with a dreamy blue haze that softened their outlines, making them inexpressibly lonesome and mysterious. Their slopes were covered with gigantic oaks five and six feet in diameter, chestnuts one hundred feet tall (the blight had not yet killed off these majestic trees), sycamore, elm, gum, willow, and a dozen other species. The undergrowth below was of an almost tropical luxury, and the gorges were choked with laurel and rhododendron. What land was cleared had been made so by the ancient method of girdling the trunks of the great trees so they would gradually die and fall. The fields were plowed with a "bull tongue," an implement that was little

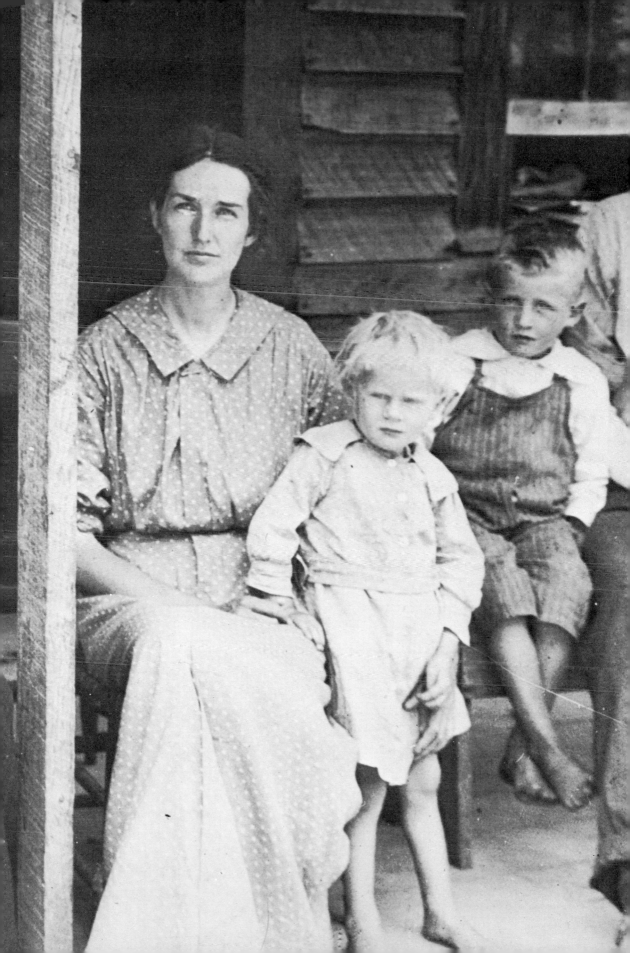

more than a sharpened stick with a metal rim, and once the corn was up it was cultivated with hoes by the entire family. When the thin soil wore out, the mountain people went on to another piece of land. "When I move," one man told Kephart, "all I have to do is put out the fire and call the dog." On the average, the highlander was inquisitive, shrewd, and lean—rarely did Kephart see a fat one. Like Indians, the men had been trained to hide their emotions, and many wore a habitual scowl, greeting strangers with hard, searching eyes. (Edgar Allan Poe, writing in 1845, had thought the mountains "tenanted by fierce and uncouth races of men.") The women were pretty when young, but they aged cruelly fast; generally by the time she was in her thirties a mountain woman was painfully bent and old from continuous hard work, early marriage, and frequent childbearing. Despite their poor diet and frequent illnesses, however, many of the mountain folk had great physical energy and were capable of enduring extraordinary hardship. Men who had forded icy mountain streams all day would return home at sunset to dry out before a log fire in a drafty log cabin; herdsmen who stayed with their animals in mountain pastures rarely carried a blanket with them, but slept uncovered in every kind of weather; few mountaineers wore rain gear or even a coat, and adults and children sometimes went barefoot through much of the winter, often tramping without shoes through ankle-deep snow. One woman Kephart met—"Long Goody" she was called, for her six-foot, three-inch height—customarily walked eighteen miles to market across a five-thousand-foot summit and returned the following day carrying a fifty-pound sack of flour and other groceries.

Constant exposure and inadequate clothing produced the "rheumatiz"; the "milk-sick" (which carried off Abraham Lincoln's mother) was a common ailment; and a steady diet of pork fat, corn pone and doughy biscuits, green beans, and pot liquor resulted inevitably in dyspep-

sia. The most primitive remedies were employed for injuries—wounds were staunched with dusty cobwebs and bound up with old rags—and seldom was any sympathy shown for an injured person, or much emotion for the dead. Suspicious of even the most rudimentary medical treatment, few mountain people would accept an anesthetic, even for major operations. And when dentistry was necessary, teeth were sometimes removed by a method known as "tooth-jumping," in which a handmade nail was set against the tooth at a certain angle and hit a sharp blow with a hammer.

Their homes were log cabins that customarily had one large room with a stone chimney at one end and a single window sash at the other, a plank door, and a lean-to at the rear for a kitchen. Few of these structures were effectively chinked, and since they were usually made of green timbers, the house warped and sagged, the roof leaked, and the flooring shrank. On the walls of the main room, above the beds or pallets, the family wardrobe hung from pegs, along with herbs, apples, and gourds that were drying there. Most houses had a bright lithograph or two on the wall or a family photograph taken by an itinerant photographer like Barnhill. The Bible, an almanac, and a kerosene lamp were standard fixtures, and more often than not there was a spinning wheel or hand loom in evidence.

Outside the cabin was a variety of equipment for the necessities of life: a tub-mill for grinding corn; an ash hopper for running lye to make soap; a cider press (the photograph on page 165 shows a highlander pressing apple juice by a crude method of weighted leverage that dated back to Biblical times, when olives were pressed in the same manner); a spring box for water and for cold storage in summer; an immense iron kettle for boiling clothes, making soap, scalding pigs, and other uses; and a "battlin' block" on which the family wash was hammered. Somewhere in or near the clearing, chickens ran

wild; beyond, in the undergrowth, was a litter of razor-back hogs, the mountain family's mainstay; and off in the primeval forest roamed a herd of scraggly mountain cattle. What trade there was was by barter, and every man had to be his own gunsmith, carpenter, cobbler, and blacksmith. An occupation common to the area is shown in the photograph on page 163, where an old man splits white oak into splints for baskets. An experienced eye was needed to select the right type of tree for this purpose, and there was a proper time for felling it so that it could be worked to best advantage. The splints, which had to be straight-grained, were soaked in water until they were pliable enough to be woven into baskets or other containers. Used for gathering fruit, measuring grain, and toting in general, the baskets were woven from these splints, some of them natural, some dyed to create a pattern by one of the many native methods of obtaining fast colors from local roots and barks (an example of the work is in the woman's hands, on page 157). It was astonishing how many necessities of life could be fashioned from materials that were readily available: at the side of the Civil War veteran on page 151, the top of a bark bucket is just visible; these containers were made of green flexible bark, which was folded to form the bottom and then stitched together with thongs.

It was a patriarchal society in which all men were equal and women were second-class citizens. With everyone in the same fix of poverty and deprivation, life was not so bad, and the mountain people, born and bred to self-denial, had a real scorn for luxury. The word of the head of the household was law. "The woman," as every wife was called, was both household drudge and field hand; before "store clothes" became cheap and easy to obtain, she produced the dresses and homespun jeans and linsey-woolsey her family wore, and the quilts under which they slept (in fact, one household might contain an entire industry; the photograph on pages 168 and 169 shows the

carding of wool, by the woman at the head of the stairs, the spinning of yarn, at center, and the weaving, on a homemade, heavy timbered loom, at left. The finished product was the coverlet or bedspread shown at far right). She helped with the plowing and planting, hoed the corn, gathered the crops, chopped firewood; and at mealtime she stood and waited table, serving her man first. She commonly bore between seven and ten children, but the mortality of the infants was appallingly high. Life was hard and often cruel, and both men and women wore the stamp of old age early. Like so many of the younger women, the one pictured on page 149 was quite pretty; but before long she would begin to resemble the toothless old granny on page 153, knitting with arthritic hands.

The manners and morals of these folk were those of their distant forebears—so vividly described by Fielding and Pepys—and their language was a direct tie to fifteenth-century England. Words that had been obsolete in the old country for years still persisted in the southern Appalachians: *dauncy*, meaning fastidious, or overnice, dated back at least to 1460; *doney* or *doneygal*, meaning a sweetheart, came from the Spanish *dona*, and had been brought back to English ports centuries earlier by British sailors; people spoke of *backing* letters, which came from the days before envelopes, when the address was written on the back of the letter. Almost all the place names of their world were descriptive—Black Rock, Standing Stone, Burnt Cabin Branch, Bear Wallow, Pretty Hollow, Brier Knob—reflecting the constant proximity of the people to nature. Their talk was full of terms that meant little to an outsider but were of the essence to a highlander: *bald*, meaning a treeless mountain top; *bench*, a level area on the side of a mountain; *drain* (pronounced *dreen*), a small spring on a mountainside; *butt*, the abrupt end of a mountain ridge; *scald*, a bare hillside; *deadening*, an area where the trees had been killed by girdling, to

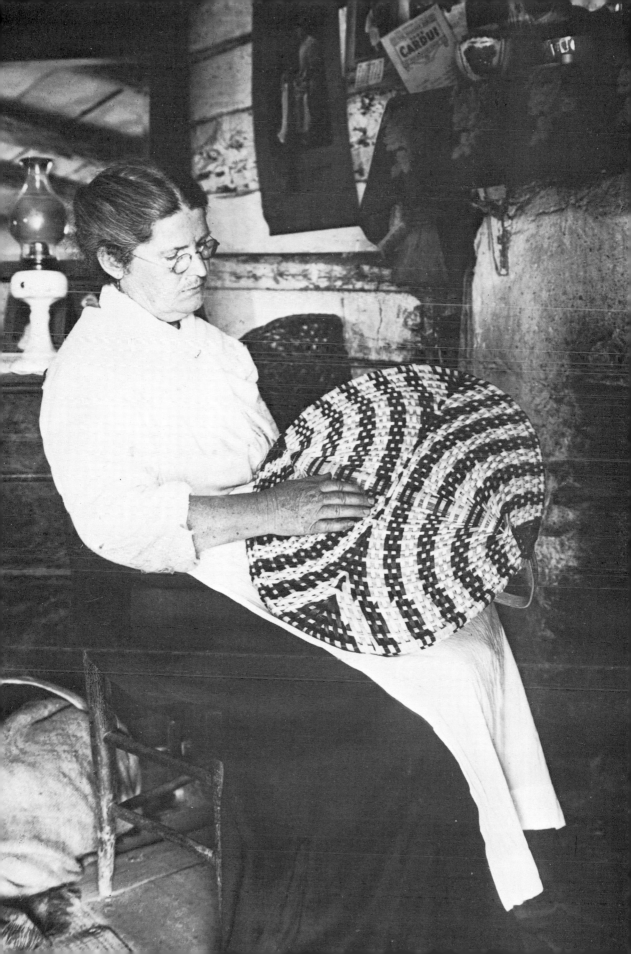

clear the land for farming. A *gritter* was a grater used for making grits; a *piggin* was a small wooden bucket or churn; *daubin'* was the mud used to plaster a chimney; *leather britches* were beans dried in the pod and boiled.

Some of the rumors about the mountain people that reached the outer world were true, or had their basis in fact—the dark tales of blood feuds and incestuous family relationships, the jokes about moonshiners and "reve-nooers." Segregated from outsiders, the mountain folk were indeed a distinct species, unmixed ethnically, with strong ties of kinship not unlike the old Scottish clan loyalty. Harsh physical circumstance was responsible for the inbreeding and genetic mistakes that resulted; it was equally responsible for confused land titles that led often to murderous feuds; and it forced the proximity that led to many of the drunken rows and card disputes. In the mountain code of conduct, burglary was unheard of, but a man would kill his neighbor over ownership of a pig. Hospitality was a sacred obligation, but it was also ex-pected that a stranger approaching a mountain cabin would halloo until someone came out to inspect him.

In a perverse and curious way, the subject of whiskey is part and parcel of the story of the highlanders. Whiskey meant a great deal to them: in a region where it might take a doctor three days to reach a dangerously sick or injured person, it served as palliative and anesthetic. It was, in the real sense of the phrase, a pain killer. It was easy for the farmer to produce and it was usually his only cash crop. The mountain roads were so abominable that no quantities of farm produce could be hauled out to the civilized world, so "corn juice" became, from earliest time, the product that was traded for cash or goods.

The Scotch-Irish who came to America in the eighteenth century soon discovered that all the good land on the eastern seaboard was taken, so they fanned out in the direction of the Appalachians. Driving out the Indians, they settled the Alleghenies; from there, when the game

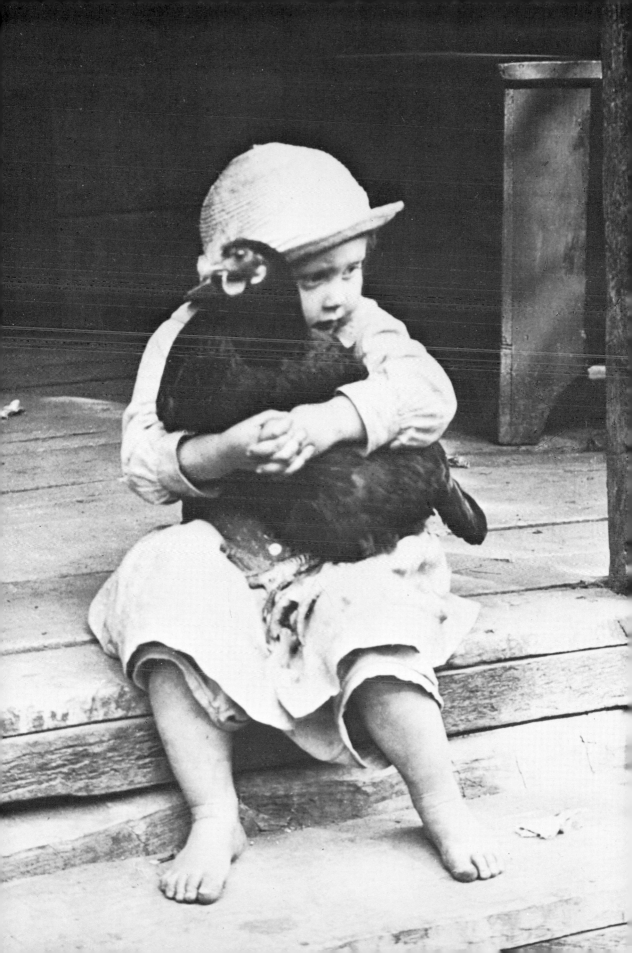

was gone, the more ambitious or restless headed west again. But some stayed behind: they were the men who fought as riflemen in the Revolution and carried the day at Saratoga and at Kings Mountain, who went back to the hills after that war to take up life in the old way (which was to say, under their own set of standards or laws). Unknowingly, they had helped remake the outside world, and in 1791, when the new federal government passed a law imposing a tax on whiskey of nine to eleven cents per proof gallon, the mountain people rose in opposition to governmental authority and its power to tax them. One thing the Scotch-Irish had brought with them to America was an abiding hatred of the British government and its excise laws, plus a tradition of resistance to all who attempted to enforce those laws; the new government in Philadelphia did not find them any more tractable than had George III.

Albert Gallatin, a western Pennsylvania farmer who was to become Jefferson's Secretary of the Treasury, defended the frontiersmen as the Whiskey Rebellion erupted. "We have no means of bringing the produce of our lands to sale either in grain or in meal," he argued. "We are therefore distillers through necessity, not choice, that we may comprehend the greatest value in the smallest size and weight." It was difficult for the mountain farmer to understand why he should pay a tax on what he made: when he harvested and shucked and ground his corn to be baked into bread by his woman, he paid no tax on that. Why should the government collect an excise on another product made from the same corn?

The financial cost of George Washington's expedition against the Whiskey Boys was more than one third of the total expenditures of the government of the United States that year. The government proved its point—that it could enforce the law of the land and preserve domestic tranquillity—but the result in the mountains was an enduring hatred of federal authority that had political as well as

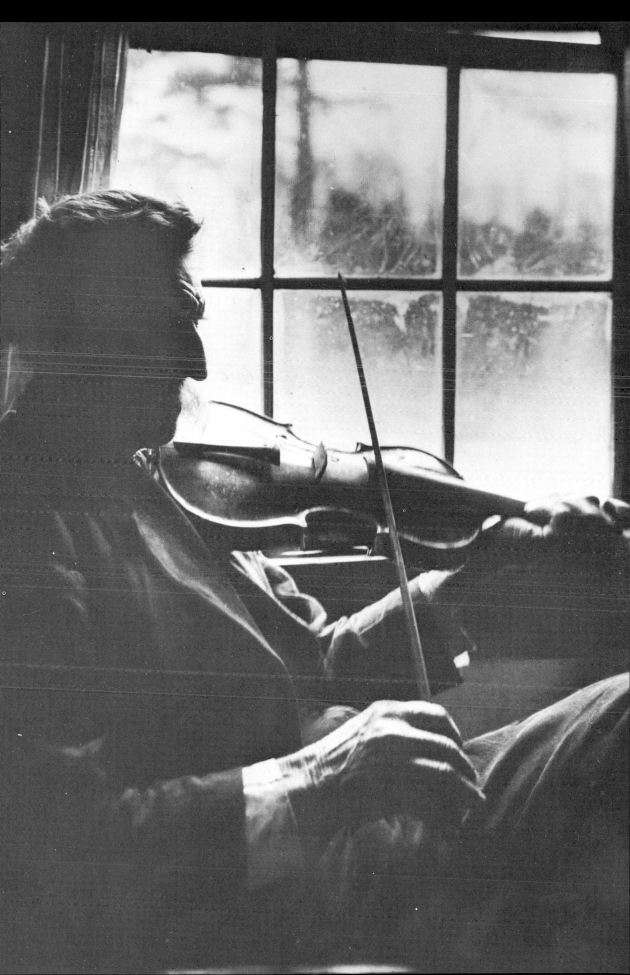

social repercussions. Rather than submit, some of the stubbornest Pennsylvania malcontents picked up their belongings and their stills and moved to western Virginia and the Carolinas, where it was unlikely that any serious government effort could be made to collect the odious excise. The moonshiner called himself a blockader and his product blockade liquor; he regarded himself as a blockade-runner dealing in contraband. Back in the mountains he and his descendants remained, obstinate and self-reliant, as independent—in their phrase—"as a hawg on ice," their life a hard, cruel war against the elemental forces of nature. As the years passed they stayed on for a variety of reasons. Isolation from the outside world kept them ignorant of the opportunities it afforded, and their poverty was such that they would have had no money with which to migrate, in any case. Passionately attached to their homes, their kinfolk, and the old-fashioned ways, they were without ambition because nothing in their environment inspired it. While other Americans grew in wealth and education and culture, the mountain people stood still or retrogressed.

Despite their earlier resistance to the government, during the Civil War the mountain residents of eastern Tennessee were loyal to a man; West Virginia became a separate state when its people "seceded from secession," as someone put it; and in Jackson County, Kentucky, Lincoln's call for troops depleted the county of every able-bodied male under sixty and over fifteen. Although the region's loyalty astonished both North and South, at least two factors were apparently at work: the national feelings dating back to the Revolution had never vanished —the ideal of a nation was one to which the mountain folk clung with fierce pride; and their belief in freedom and in the principle that one man was the equal of all others put them squarely on the side of Abraham Lincoln. It was all right for a person to hold property, they reasoned, but not to own another man.

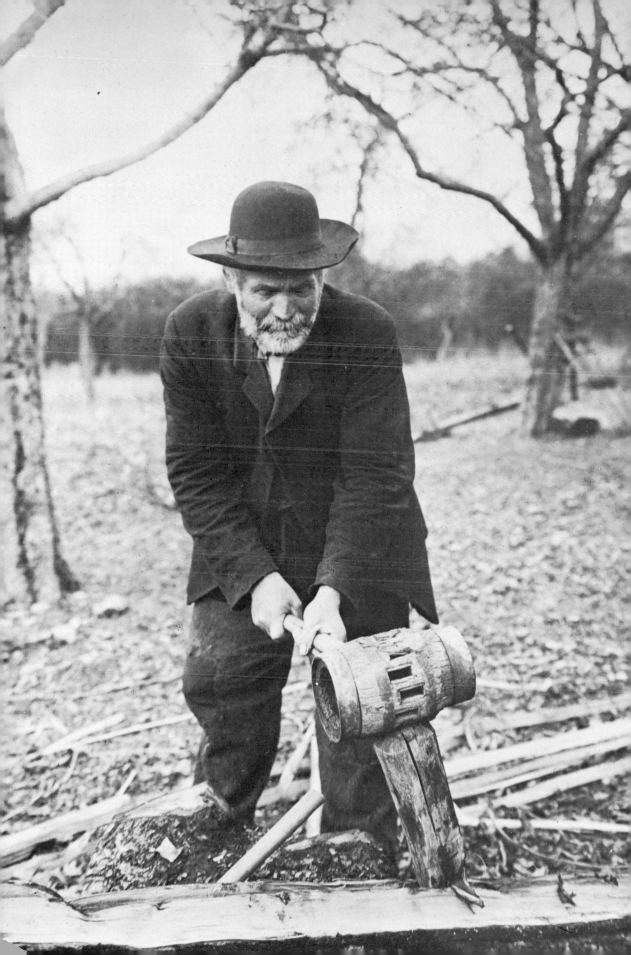

After Appomattox, as after Yorktown, they returned to their mountain fastness, and once more the world passed them by until a few curious outsiders made their way up the steep ravines to observe and record a society and a way of life that had existed nowhere else for two centuries. At the time Kephart and Barnhill visited Appalachia, they found a great landlocked area that was more English than England, more American by blood than any other section of the country, and less affected by modern ideas or progress than any part of the English-speaking world. And so, for several decades more, it remained. But the way of life of the mountain people, inaccessible as it was, could not resist indefinitely a rapacious outside world. With each passing year there were fewer truly isolated settlements; electricity, then radio and television, became available; more and more highways penetrated the wilderness; the tourist demanded motels, restaurants, and shops filled with the old handicrafts.

Progress, as it is called, improved the harsh conditions of life but little, as demographic statistics suggest. The 1960 census revealed, for example, that the median income in the mountainous western counties of North Carolina was still well below the state level and less than half the national figure. Educationally, the area was not much better off: the rural counties' level of schooling was two to three years below the national average; overcrowding, teacher shortages, and inadequate facilities were prevalent, and the incidence of dropouts was high. Although there had been some improvement in the availability of medical care, doctors and dentists were still in short supply, and the health of the people remained noticeably poor, with high rates of tuberculosis and infant mortality. Unemployment was appreciably higher than the national mean in 1960, and unfortunately, the activity that accounted for nearly half of what employment there was in the mountain counties—small farming—was a marginal operation, with less and less

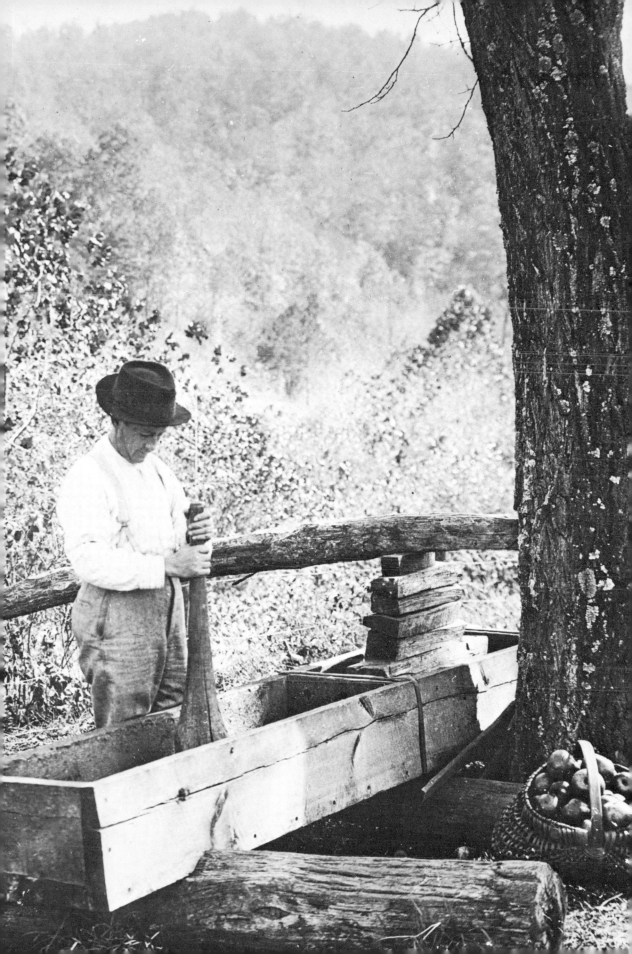

chance of survival in a highly mechanized society.

The 1960 census indicated that the mountain regions were still inhabited largely by the old white stock. Yet while the ethnic complexion remained unchanged, the effect of continuing poverty and hardship has been to drive people out. During the decade between 1950 and 1960 the fifteen counties of North Carolina's western tier suffered a population loss of 3.7 per cent, while the major city in the area, Asheville, showed only a slight gain— 4.6 per cent. These figures, in marked contrast to the national population increase of 18.5 per cent during the same period, indicated a substantial migration of people from the area. In fact, five of the mountain counties lost more than ten per cent of their population between 1950 and 1960, and it has been estimated that as much as one fourth of the entire population may have left the area between the end of World War II and 1965.

Unfortunately, those who left were often the young and ambitious, those with higher than average intelligence and initiative. Many of them moved to nearby urban centers—Winston-Salem, Greensboro, Charlotte, or Columbia, South Carolina—where factory jobs beckoned. Others went farther—to Cincinnati and Chicago, two cities that were cited in 1960 as having "hillbilly slums." Tragically, many of those seeking opportunity in the cities found none, for there was already unemployment there, and their skills were often woefully inadequate. In the long term—months, years, possibly a generation—the experience of other migrants would suggest that these regional moves might eventually produce some, if not all, of the results the people sought when they left their traditional homes; but on the basis of their prior two-hundred-year history, it would be rash to predict that the people of the southern mountains would adjust easily or readily to life in the outside world.

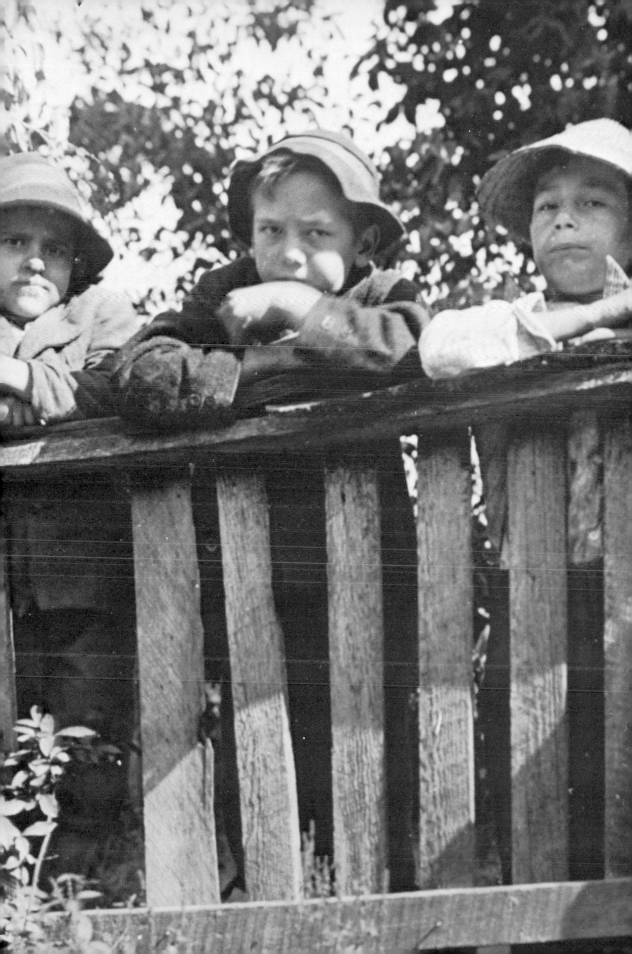

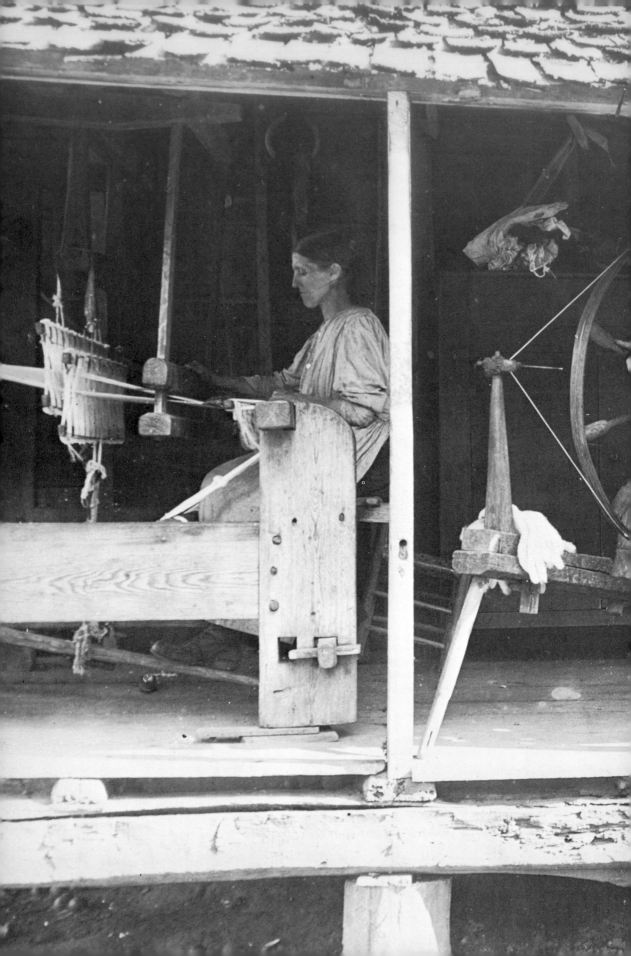

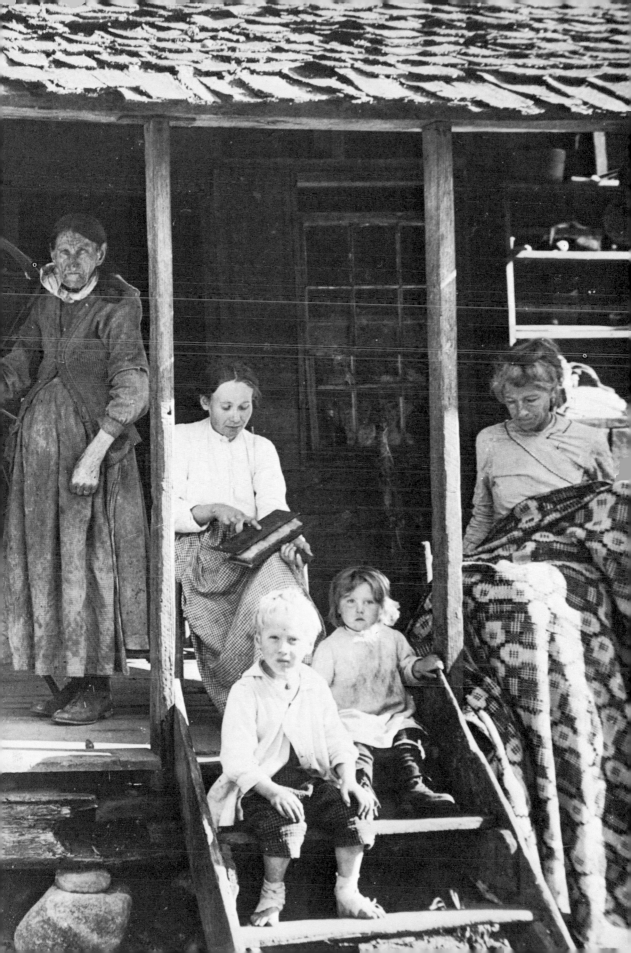

ACKNOWLEDGMENTS

Not until the summing up was at hand did I realize the extent of my indebtedness to those who have been helpful in some way in the preparation of this book. The credit accompanying each photograph gives no indication of the cooperation that was usually extended so willingly by the source, nor does it hint at the long, troublesome search or the time-consuming correspondence in which a simple request sometimes resulted. To all those individuals, institutions, and collections that have been so obliging go my sincere thanks.

Others have been equally generous in giving of their time and counsel. In particular I should like to thank the editors and the staff—present and past—of *American Heritage* Magazine, in whose pages a number of these "Faces" appeared. Not only did they assist me in many ways, they also preserve a climate of affection for the marvelous old photograph and the curious tidbit from the past. I am especially indebted to Oliver Jensen, who has been a fund of ideas and support from the time the articles first ran in the magazine. These pieces have all been entrusted to Murray Belsky, the Art Director at American Heritage, who has handled the layout, cropping, and reproduction of the photographs with great sensitivity and care. He has been a constant source of gentle advice, and to him belongs the credit for the design and appearance of this book. For her advice and suggestions, I owe special thanks to Mrs. Joan Kerr, who knows as much about pictorial sources as anyone in the land and who has made the collecting of such materials into an art. My gratitude goes to Miss Mary Elizabeth Wise, not only for typing much of the manuscript, but for handling so ably and cheerfully a multitude of other tasks, including locating pictures, books, and other materials I needed, and obtaining, from many sources, permission to reproduce the photographs.

Bruce Catton has been a source of inspiration and wise counsel. Robert Reynolds, E. M. Halliday, and Eric Larrabee were unfailingly helpful and provided valuable criticism. Among the many friends and colleagues who gave me suggestions for subjects are Stephen Sears, Alvin Josephy, David

McCullough, and David Lowe, to each of whom, thanks. I owe much to various members of the American Heritage library staff for their uncomplaining efforts to obtain books and photographs—in particular, Mrs. Caroline Backlund, Mrs. Timmie Blumstein Rome, Mrs. Peggy Buckwalter, and Miss Laura Layne. Douglas Tunstell, Miss Carla Davidson, and Mrs. Constance Corning also assisted with pictorial and other research for the book, and Mrs. Louisa Bonner typed portions of the manuscript and provided numerous suggestions. Among those in the copy department who have tried to keep the manuscript free from error are Miss Beverly Hill, Mrs. Brenda Niemand, Mrs. Carol Angell, Mrs. Mary Sachs, and Miss Helen Dunn. I appreciate their efforts.

Mrs. Dorothy Meserve Kunhardt, who has a passionate interest in the faces of America's past, has been extremely helpful in providing information and encouragement. I am also indebted to Miss Josephine Cobb, Lloyd Ostendorf, Beaumont Newhall, and Freeman Hubbard for answers to specific—and not always easy—questions concerning pictures. Evan Thomas and Raymond Fosdick generously came to my assistance when I was seeking material about Norman Thomas. Radford B. Curdy offered to let me reproduce the photograph of Major John Livingston and gave me information concerning the old man. Through a suggestion from Miss Romana Javitz, formerly of the New York Public Library Picture Collection, I had the good fortune to communicate with William Barnhill, whose pictures appear on pages 146 to 169, and to that introduction I owe the pleasure of a continuing correspondence and a warm friendship.

Not many of the photographers whose work appears here are still with us; a few fortunately are. To all of them, present and departed, I am grateful for the hours of pleasure and the inspiration their pictures have given me.

The one person who has read all this material, in many different versions, is my wife, Barbara Bray Ketchum. Her keen judgment and her unerring eye for the murky phrase or the sentence that does not ring true have been of more help than I can possibly acknowledge here.

To all these people I am deeply indebted. It goes without saying that any faults the book has are not theirs but are the responsibility of the author.